The Rem

· · · · ·

Victor Burgin

The Remembered Film

REAKTION BOOKS

Published by Reaktion Books Ltd
33 Great Sutton Street
London EC1V 0DX, UK

www.reaktionbooks.co.uk

First published 2004, reprinted 2004, 2006

Printed and bound in Great Britain
by Biddles Ltd, King's Lynn

British Library Cataloguing in Publication Data
 Burgin, Victor, 1941–
 The remembered film
 1. Motion pictures – Psychological aspects 2. Motion pictures –
 Appreciation 3. Recollection (Psychology)
 I.Title
 791.4'3'019
 ISBN 1 86189 215 2

Contents

1 Introduction
The Noise of the Marketplace

It is as if one saw a screen with scattered colour-patches, and said: the way they are here, they are unintelligible; they only make sense when one completes them into a shape.—Whereas I want to say: Here is the whole. (If you complete it, you falsify it.)

Ludwig Wittgenstein[1]

The cinematic heterotopia

Early in the history of cinema, André Breton and Jacques Vaché spent afternoons in Nantes visiting one movie house after another: dropping in at random on whatever film happened to be playing, staying until they had had enough of it, then leaving for the next aleatory extract. The movie theatre offers a refuge from the tedium that dogs metropolitan heels on provincial streets. If however, even within the cinematic sanctuary, boredom tugs at the sleeve it is best to pull free, unstick oneself from the narrative and take off for the next distraction. But more than boredom is at issue in Breton's and Vaché's cinema-hopping. Later in the history of cinema Raoul Ruiz went to see films set in Classical antiquity with the sole desire of surprising an aircraft in the ancient heavens, in the hope he might catch 'the eternal DC6 crossing the sky during Ben Hur's final race, Cleopatra's naval battle or the banquets of *Quo Vadis*'[2] – and Roland Barthes at the cinema found himself most fascinated by 'the theatre itself, the darkness, the obscure mass of other bodies, the rays of light, the

entrance, the exit' (see 2, 'Barthes' Discretion').[3] Inventions of the recalcitrant, such viewing customs customize industrially produced pleasures. They are examples of what Michel de Certeau has described as 'quasi-microbian operations that proliferate at the interior of technocratic structures and divert [*détournent*] their functioning by a multitude of "tactics" fashioned from the "details" of daily life'.[4] Breaking into and breaking up the film, they upset the set patterns that plot the established moral and political orders of the entertainment form of the *doxa*.[5] During the more recent history of cinema, less self-consciously resistant practices have emerged in the new demotic space that has opened between the motion picture palace and consumer video technologies. Few people outside the film industry have had the experience of 'freezing' a frame of acetate film, or of running a film in reverse – much less of cutting into the film to alter the sequence of images. The arrival of the domestic video cassette recorder, and the distribution of industrially produced films on videotape, put the material substrate of the narrative into the hands of the audience. The *order* of narrative could now be routinely countermanded. For example, control of the film by means of a vcr allows such symptomatic freedoms as the *repetition* of a favourite sequence, or *fixation* upon an obsessional image.[6] The subsequent arrival of digital video editing on 'entry level' personal computers exponentially expanded the range of possibilities for dismantling and reconfiguring the once inviolable objects offered by narrative cinema. Moreover, even the most routine and non-resistant practice of 'zapping' through films shown on television now offers the sedentary equivalent of Breton's and Vaché's ambulatory *dérive*. Their once avant-garde invention has, in Viktor Shklovsky's expression, 'completed its journey from poetry to prose'. The decomposition of narrative films, once subversive, is now normal.

Films are today dislocated and dismantled even without intervention by the spectator. The experience of a film was once localized in space and time, in the finite unreeling of a narrative in a particular theatre on a particular day. But with time a film became no longer simply something to be 'visited' in the way one might attend a live

theatrical performance or visit a painting in a museum. Today, as I wrote in a previous book:

> a 'film' may be encountered through posters, 'blurbs', and other advertisements, such as trailers and television clips; it may be encountered through newspaper reviews, reference work synopses and theoretical articles (with their 'film-strip' assemblages of still images); through production photographs, frame enlargements, memorabilia, and so on. Collecting such metonymic fragments in memory, we may come to feel familiar with a film we have not actually seen. Clearly this 'film' – a heterogeneous psychical object, constructed from image scraps scattered in space and time – is a very different object from that encountered in the context of 'film studies'.[7]

Film studies must now confront as heterogeneous an 'object' as that which confounds photography and television studies – in fact it is largely the same object. In the final paragraph of his comprehensive review of a half-century of film theory, Francesco Casetti writes:

> For a long time cinema has not been identified with one kind of film: it is a fictional full length movie, but also an experimental work, an amateur's 8-millimeter production, an ethnographic documentary, a teaching tool, an author's test run. Now cinema is not even identified exclusively with movies . . . Experiences that cinema made known return in the form of exotic mass-vacations, in video clips, in the special effects of business conventions . . . Further, cinema in turn follows publicity, magazines, games, television. It no longer has its own place, because it is everywhere, or at least everywhere that we are dealing with aesthetics and communication.[8]

The 'classic' narrative film became the sole and unique object of film theory only through the elision of the *negative* of the film, the space

beyond the frame – not the 'off screen space' eloquently theorized in the past, but a space formed from all the many places of transition between cinema and other images in and of everyday life. Michel Foucault uses the term 'heterotopia' to designate places where 'several sites that are in themselves incompatible' are juxtaposed.[9] Incommensurability of elements makes the heterotopia a site of instability and contravention. Although set apart from the habitual habitat, heterotopias nevertheless have multiple relations with other sites – for example, Foucault considers the ship 'the heterotopia *par excellence*' in that it is a heterogeneous 'place without a place' which may touch many places.[10] The term 'heterotopia' comes via anatomical medicine from the Greek *heteros* and *topos*, 'other' and 'place'. I am reminded of the expression *einer anderer Lokalität* by which Freud referred to the unconscious. Although Foucault explicitly applies the concept of 'heterotopia' only to real external spaces, he nevertheless arrives at his discussion of heterotopias via a reference to *utopias* – places with no physical substance other than that of representations: material signifiers, psychical reality, fantasy. What we may call the 'cinematic heterotopia' is constituted across the variously virtual spaces in which we encounter displaced pieces of films: the Internet, the media and so on, but also the psychical space of a spectating subject that Baudelaire first identified as 'a *kaleidoscope* equipped with consciousness'.

Roland Barthes describes how one evening, 'half asleep on a banquette in a bar', he tried to enumerate all the languages in his field of hearing: 'music, conversations, the noises of chairs, of glasses, an entire stereophony of which a marketplace in Tangiers (described by Severo Sarduy) is the exemplary site'. He continues:

And within me too that spoke (it is well known), and this speech called 'interior' very much resembled the noise of the marketplace, this spacing of little voices that came to me from outside: I myself was a public place, a souk; the words passed through me, small syntagms, ends of formulae, and *no sentence formed*, as if that were the very law of this language.[11]

This 'language' is 'lexical, sporadic',[12] and constitutes a 'definitive discontinuity' in him. Its component 'non-sentence' is not a preliminary to the sentence, something that lacks the power to accede to the sentence, it is rather 'eternally, superbly, *outside the sentence*'. Here, writes Barthes, 'all of linguistics falls, which believes only in the sentence', for the sentence 'is hierarchical: it implies subjections, subordinations'. Above all, the sentence is that which is *completed*.[13] In referring to 'this speech called "interior"'[14] Barthes most probably alludes to the Russian linguist Lev Vygotsky, who coined the expression 'inner speech'. Unlike externally directed communicative speech, Vygotsky writes, inner speech 'appears disconnected and incomplete'.[15] Vygotsky's 'inner speech' is the adult survival of what Jean Piaget calls the 'egocentric speech' of the small child. In psychoanalytic terms it represents the persistence of the 'primary processes' that historically precede 'secondary' modes of thought – preferring images to words, and treating words like images. When Vygotsky notes that in inner speech, 'a single word is so saturated with sense that many words would be required to explain it in external speech',[16] we may suppose that he refers to that same mechanism that Freud terms 'condensation', that which renders the dream 'laconic' in comparison to the wealth of dream-thoughts.[17]

Eyes half closed, Barthes sees a homology between the cacophony of the bar and his involuntary thoughts, and finds that no 'sentence' forms. When Stanley Kubrick's film *Eyes Wide Shut* (1999) was released one reviewer compared it unfavourably to its source in Arthur Schnitzler's novella *Dream Story*.[18] He observed that Schnitzler's narrative consists of a series of disconnected incidents that the writer nevertheless unifies into a meaningful whole through the continuous presence of the narrator's voice. The reviewer complained that Kubrick's retelling of the story suffers from the absence of this device, and that as a result the narrative remains disturbingly disjointed. The 'disjointedness' that the reviewer found in Kubrick's film might be seen as a structural reflection within the film of its own immediate exterior, the *mise-en-abyme* of its existential setting.

A short trailer for *Eyes Wide Shut* played in cinemas for several weeks before the film was released. It showed the two principal actors embracing in front of a mirror while a pulsing rock and roll song plays on the sound track. A still from this same sequence appeared throughout the city (Paris in this instance) on posters advertising the film. For several weeks *Eyes Wide Shut* was no more than this poster and this trailer. When the film finally came to the cinema the short sequence was discovered embedded in it. From poster to trailer to film there was a progressive unfolding: from image, to sequence, to concatenation of sequences – as if the pattern of industrial presentation of commercial cinema were taking on the imprint of psychical structures: from the most cursorily condensed of unconscious representations to the most articulated conscious forms, as if the 'noise of the marketplace' in the most literal sense was conforming to the psychological sense of Barthes' metaphor. Opened onto its outside by the publicity system, the film spills its contents into the stream of everyday life, where they join other detritus of everyday experience ('small syntagms, ends of formulae') and where no sentence forms.

The purported 'disjointedness' in Kubrick's film may also be understood as a product of an evolution in ways of narrating in course since the inception of cinema, a once orderly process now producing random mutations in reaction to a changed environment. Evidence of such narrative shape-shifting was even more pronounced in two other films I saw in Paris during the summer that I saw *Eyes Wide Shut*. Noémie Lvovsky's film *La Vie ne me fait pas peur* (1999) tells the story of four girls, close friends, as they make their way through adolescence to young adulthood. The 'story' consists of a concatenation of scenes that have all the appearance of having been improvised. Each seems able to stand on its own, independently of the others. The connective tissue of the narrative must be supplied by the spectator as she or he infers what might or must have taken place between scenes. Temporal sequence is indicated only by changing fashions as we move from the 1970s into the '80s, and even this index is unreliable since we live in a period in which disparate 'retro' styles parade simultaneously on the

same stage. The superimposition of oneiric temporal schemas upon the linear time of classical narrative cinema is further exemplified in Chantal Akerman's *Portrait d'une jeune fille de la fin des années 60, à Bruxelles, Avril 68*. This short film, made for television in 1994, is seamlessly unitary in action, time and space. But although (as the title is at length to point out) the story is ostensibly set on the eve of the 'events of May' 1968, cars of the 1990s pass in the street where Michèle tells Paul of her recent participation in an anti-Vietnam War rally, and when the couple go to bed together they first put on a disk of Leonard Cohen's 'Suzanne' in the form of a CD – a technology that Sony would introduce to the public only in 1982.

Now, years after *Eyes Wide Shut* has all but disappeared from the movie theatres, debris from the big bang of its publicity explosion continues to drift through virtual space. Copying the title of the film from a page on my word processor into an Internet search engine produced 76,200 results in 0.18 of a second. Seconds later I had downloaded a QuickTime movie of the 'mirror scene' trailer. Discussions of the effects of computer technology on cinema have tended to be dominated by questions of industrial production. For example, a near future is envisaged in which films are made, distributed and projected entirely in digital form; and a more distant future in which live actors are replaced by computer simulated 'synthespians'.[19] But we may also consider the ways in which individual personal uses of the computer may be producing mutations in narrative forms. As a delivery system, the Internet offers video *bricoleurs* and artisans of *détournement* with a source of clips from both old and new film releases;[20] as an environment, it has become the site of modes of telling that owe little to traditional narrative practices. For example, in 1996 an American college student attached a video camera to her computer and began to upload images of her dormitory room to the Internet. Since then, images of her formerly private domestic life have been available any time of day or night to anyone able to log on to her website (see 3, 'Jenni's Room').[21] At the inception of this since widely emulated and commercialized initiative, the young woman's 'real

time' presentation of her own life was transmitted as a series of 'snap-shot' still images taken at the rate of one every three minutes. There are a number of websites where these images are archived, all tagged with date and time: the dormant components of a potential filmic narration of a life passed in time-lapse. Describing the source of his own interest in the 'JenniCam' site, one of her 'fans' writes: 'It's fascinating! It relates closely to work being done by several visual artists I know who are interested in narrative'.[22] Just as Breton's and Vache's once avant-garde practice has become a routine mode of spectatorship, so everyday computer practices are engendering narrative forms that might once have been received as avant-garde rejections of the representational regimes of classical realist cinema.

The sequence-image

In its random juxtapositions of diverse elements across unrelated spatial and temporal locations, our everyday encounter with the environment of the media is the formal analogue of such 'interior' processes as inner speech and involuntary association.[23] These tend away from the causal linear progressions of secondary process thought towards the extremity of the dream – which, Freud emphasizes, is to be understood not as a unitary narrative but as a fragmentary *rebus*. The primary processes of the dream-work are those of the unconscious in general. Barthes writes that, within him, 'that spoke' – 'cela parlait', evoking Lacan's 'Ça parle'.[24] Jean Laplanche and Serge Leclaire describe the 'words' that compose unconscious discourse as 'elements drawn from the realm of the imaginary – notably from visual imagination'; they describe the 'sentences' formed from these words as 'short sequences, most often fragmentary, circular and repetitive'.[25] Clearly, the 'sentences' to which Laplanche and Leclaire refer are equivalent to the 'small syntagms, ends of formulae' that Barthes insists are 'outside the sentence', beyond linguistics. The minimal sequences of which Barthes speaks are typical of the reiterative fractional chains that form unconscious fantasies.[26]

As Laplanche and Pontalis note, when Freud speaks of unconscious fantasy, 'he seems at times to be referring to a subliminal, preconscious, revery into which the subject falls and of which he may or may not become reflexively aware'.[27] 'Half asleep' – which is to say in a 'subliminal, preconscious, revery' – Barthes is struck by a homology between the cacophony of the bar and his involuntary thoughts. The phenomena of everyday life form an amalgamated field of broadly isomorphic endogenous and exogenous impressions. This field is the source of what Freud calls the 'day's residues' – remnants of the day preceding the dream that enter the analysand's account of the dream, and her or his consequent associations. These residues are mental images, not necessarily visual (they may be auditory, tactile, olfactory, enactive or kinaesthetic); nevertheless, visual images predominate.

The oneiric aspect of the cinematic heterotopia is a matter not only of forms but of contents. Barthes on the banquette compares his inner 'souk' with the noise of his immediately external surroundings, and the two together form a unitary field. In addition to the determinations of what Barthes elsewhere calls the 'already read' and 'already seen',[28] personal memories and fantasies will provide the narrative kernels and principles of organization of any more or less coherent structures that emerge within this field. Jean Laplanche speaks of memory and fantasy as a 'time of the human subject' that the individual 'secretes' independently of historical time. Temporal 'secretions' very often combine memories and fantasies with material from films and other media sources. For example (the autobiographical is the appropriate mode here), my mother was in an air-raid shelter, and I was in her womb, when her home was severely damaged by a bomb that razed a whole row of houses adjacent to the bomber's target – a nearby steelworks. I remember my mother's face pale and anxious in the gloom of the bomb shelter, and the dark shapes of those huddled around her as the bombs crashed outside. This 'memory', of course, is a fantasy with a décor almost certainly derived from a film. The temporal paradox it presents marks its debt to primary process thought. For the first four years of my life, my father was away

at war, and my mother sought distraction at the cinema. As soon as I was beyond the screaming-fit stage I became her companion there. Here is what I believe is my earliest memory of a film:

> A dark night, someone is walking down a narrow stream. I see only feet splashing through water, and broken reflections of light from somewhere ahead, where something mysterious and dreadful waits.

The telling of the memory, of course, betrays it. Both in the sense of there being something private about the memory that demands it remain untold (secreted), and in the sense that to tell it is to misrepresent, to transform, to diminish it. Inevitably, as in the telling of a dream, it places items from a synchronous field into the diachrony of narrative. What remains most true in my account is what is most abstract: the description of a sequence of such brevity that I might almost be describing a still image. Although this 'sequence-image' is in itself sharply particular, it is in all other respects vague: uniting 'someone', 'somewhere' and 'something', without specifying who, where and what. There is nothing before, nothing after, and although the action gestures out of frame, 'somewhere ahead', it is nevertheless self-sufficient. I can recall nothing else of this film – no other sequence, no plot, no names of characters or actors, and no title. How can I be sure the memory is from a film? I just know that it is. Besides, the memory is in black and white.

The memory I have just described is of a different kind from my memory of the figure of Death 'seen' by the small boy in Ingmar Bergman's film *Fanny and Alexander*, or – from the same film – my memory image of the boy's grandmother seated in a chair by a window. These examples were what first came to mind when I 'looked' in memory for a film I saw recently. They are transient and provisional images, no doubt unconsciously selected for their association with thoughts already in motion (death, childhood, the mother), but no more or less suitable for this purpose than other memories I might

have recovered, and destined to be forgotten once used. The 'night and stream' memory is of a different kind. It belongs to a small permanent personal archive of images from films I believe I saw in early childhood, and which are distinguished by having a particular affect associated with them – in this present example, a kind of apprehension associated with the sense of 'something mysterious and dreadful' – and by the fact that they appear unconnected to other memories. If I search further in my memory of childhood I can bring to mind other types of images from films. What I believe to be the earliest of these are mainly generically interchangeable pictures of wartime Britain. They form a library of stereotypes that represent what must have impressed me as a child as the single most important fact about the world around me (not least because it was offered to me as the reason for my father's absence). In addition to a small collection of enigmatic images, and a larger library of images from wartime films, I also retain other types of images from visits to the cinema in later childhood. These are neither mysterious nor generic, they tend to be associated with events in my personal history: either in direct reaction to a film, or to something that happened shortly after seeing one. Later still, from adulthood, I can recall sequences from films that have most impressed me as examples of cinematic art, and from films seen very recently but which I expect I shall soon forget. The totality of all the films I have seen derives from and contributes to the reservoir of 'already read, already seen' stereotypical stories that may spontaneously 'explain' an image on a poster for a film I have not seen, or images of other kinds encountered by chance in the environment of the media.

So far, the examples I have given are of images recalled voluntarily, and I have not spoken of their relations to actual perceptions. But mental images derived from films are as likely to occur in the form of involuntary associations, and are often provoked by external events. For example: I am travelling by train through the French countryside en route from Paris to London. Earlier, as I was waiting for the train to leave the Gare du Nord, a middle-aged couple had passed down

the carriage in which I was sitting. Something in the woman's face brought to mind an image from a film. The previous night, seeking distraction from work, I had switched on the television. The channel I selected was passing in cursory review some films to be broadcast in weeks to come: a title and a few seconds of footage from each. No doubt there was commentary *voix-off* but I had the mute on. A young woman, seen from behind, executes a perfect dive into a swimming pool; cut to the face of a middle-aged woman who (the edit tells me) has witnessed this. I read something like anxiety in her expression. The woman who had passed down the carriage had an anxious look. Now, as the train slices through the French countryside, I glimpse an arc of black tarmac flanked by trees on a green hillside. A white car is tracing the curve. This prompts the memory of a similar bend in a road, but now seen from the driver's seat of a car I had rented last summer in the South of France, where I was vacationing in a house with a swimming pool. My association to the glimpse of road seen from the train is followed by my recollection of the woman who had passed me in the carriage (as if the recollection were provoked by the perception *directly*, without the relay of the film image). Although these images have different sources I must assume that they have a common *origin* – a precipitating cause – in something unconscious that has joined them. As I recollect these associations in order to describe them, it seems that they turn around the expression on the woman's face: 'something like anxiety', but *what* is 'like' anxiety? It seems that the persistence of the images is due to this enigma.

Such spontaneous associations of elements that appear to have nothing in common may occur many times during the day. We most usually disregard them. Nevertheless, they may provide materials for subliminal reverie or a dream, or on other occasions may prompt conscious reflection and/or action. In 2001, returning to England after thirteen years in the US, I was invited to make a new video work to be shown at an arts centre in Bristol.[29] The Britain to which I returned after 'September 11' felt itself under siege for the first time in 60 years, with the difference that no one could now say to what

extent the threat was real. Travelling to Bristol by train from London, looking out at some of the most pleasant countryside in England, I recalled *Listen to Britain*, a film that begins with a similarly pastoral scene in a time of threat. The film opens with images of treetops and cornfields moving in the wind. Then the song of birds is drowned as a flight of Spitfires roars overhead. The twenty-minute black-and-white short, directed by Humphrey Jennings and edited by Stewart McAllister, was produced by the Crown Film Unit in 1942 when Britain seemed imminently at risk of invasion. I decided that what intrigued me about *Listen to Britain* was that, at a time of extreme national danger, it neither exhorts nor prognosticates; it contains neither commentary nor dialogue, and neither shows nor names the enemy. In Humphrey Jennings's picture of a nation at war, the threat of violence is everywhere but appears nowhere. This characteristic of the film seemed peculiarly apposite to the state of the nation to which I had returned. My recollection of this short film in turn led me to think of a short sequence from another film made two years later, in 1944, which again exiles war beyond the frame of an essentially rural idyll. The sequence is from Michael Powell's and Emeric Pressburger's *A Canterbury Tale*. A young woman in a light summer dress climbs a path onto the Downs above Canterbury. Emerging from a stand of

trees she is suddenly confronted with a view of the cathedral. The screen frames her face in close-up as she seems to hear ancient sounds on the wind: jingling harnesses, pipes and lutes. She turns her head swiftly left and right, as if looking for the source of the sounds – which abruptly stop as the close-up cuts to a long-shot of her alone and small in the bright expanse of grassland. The young woman on the Downs experiences the unexpected return of an image from a common national history and 'hears' sounds from a shared past that haunts the hill. On the train to Bristol I experienced the involuntary recall of her image, and others, from a shared history of British cinema.

I had a particularly clear memory of the Kent landscape in which the woman stands. But it was the memory of something I had not seen in reality. No recollection is without consequence, and we may act on our memories. Why we feel compelled, seduced or persuaded to act on *this* memory rather than some other almost always remains mysterious. On the train to Bristol, wondering where to begin the video work I had been commissioned to make, I decided to look for the location in Kent where the scene from *A Canterbury Tale* had been shot, and to make my own images of that site. My decision was over-determined by the fact that this particular scene from *A Canterbury Tale* had intermittently played in my mind over quite a long period of time

before, and I hoped thereby to exorcize it (see 4, 'The Remembered Film').

I have given two examples of train journeys interrupted by trains of associations. In both cases a concatenation of images raises itself, as if in *bas relief*, above the instantly fading, then forgotten, desultory thoughts and impressions passing through my mind as the train passes through the countryside. The 'concatenation' does not take a linear form. It might rather be compared to a rapidly arpeggiated musical chord, the individual notes of which, although sounded successively, vibrate together simultaneously. This is what led me to refer to my earliest memory of a film as a 'sequence-image' rather than an 'image sequence'. The elements that constitute the sequence-image, mainly perceptions and recollections, emerge successively but not teleologically. The order in which they appear is insignificant (as in a rebus) and they present a configuration – 'lexical, sporadic' – that is more 'object' than narrative. What distinguishes the elements of such a configuration from their evanescent neighbours is that they seem somehow more 'brilliant'.[30] In a psychoanalytic perspective this suggests that they have been attracted into the orbit of unconscious signifiers, and that it is from the displaced affect associated with the latter that the former derive their intensity. Nevertheless, for all that unconscious fantasy may have a role in its production, the sequence-image as such is neither daydream nor delusion. It is a *fact* – a transitory state of percepts of a 'present moment' seized in their association with past affects and meanings. Pierre Nora has spoken of the 'increasingly rapid slippage of the present into a historical past that is gone for good'. In the storm of representations that rages in contemporary life, the forms of continuity that were once inhabited from the inside (lived as 'traditions', or other practices of everyday life – whether to be conserved, modified or rejected) are dissolved in a mediatic solution of perpetual contemporaneity, as if the only modes of inhabiting the world were live transmission and instant replay. As a consequence, in Nora's argument, modern societies need to create 'sites of memory' because without them the events commemorated

might be effaced from recollection. Nora observes: 'There are *lieux de mémoire* because there are no longer *milieux de mémoire*.'[31] He continues:

> *Lieux de mémoire* originate with the sense that there is no spontaneous memory, that we must deliberately create archives, maintain anniversaries, organize celebrations, pronounce eulogies, and notorize bills because such activities no longer occur naturally.[32]

One class of *lieux de mémoire* consists quite literally of *places*. We hold these more or less in common with other people, and we constitute them more or less consciously. It seems that the image of a sunlit field bordered by trees has a privileged place in my own psychical life, and almost certainly in that of many others – not least those raised in cities for whom the first glimpse of countryside was a magical revelation. This is already to broaden Nora's definition of the site of memory, for although such *lieux de mémoire* are in a broad sense 'shared', their meanings may nevertheless vary widely according to the particularities of individual lives. The extent to which places evoke a more restricted public spectrum of meanings is a function of their association with common rather than individual history – as, for example, when I learn that the field before me was once an infamous battlefield (of course, public and private memories travel together, as is most apparent when they form obverse and reverse faces of the common coin of recollected films). The war memorial is perhaps the clearest example of a *lieu de mémoire* in the strictest sense of Nora's definition – constructed with no other purpose than to commemorate a specific event, and resisting any other use. But any building and any place may be *used as* a site of memory. When buildings become *lieux de mémoire*, enshrining the histories that contain them, a recollected image may serve as the catalyst that prompts remembrance and invokes the latent memorial function of architecture (see 5, 'Mies in Maurelia').

Image, image sequence, sequence-image

The sequence-image is a very different object from that addressed by film studies as the discipline re-emerged in the late 1960s and the '70s revitalized by a love affair with linguistics. Half asleep, Roland Barthes hears hybrid utterances that form no sentence. Barthes' account of his reverie on the banquette appears in his book *Le Plaisir du texte*, which was published in 1973. Ten years earlier he had been asked by the journal *Cahiers du Cinéma* whether linguistics had anything to offer the study of film. He replied that it did only if we chose 'a linguistics of the sytagm rather than a linguistics of the sign'. In Barthes' view, a linguistically informed analysis of film could not be concerned with the filmic image as such, which he considered to be pure analogy, but only with the combination of images into narrative sequences. As he expressed it, 'the distinction between film and photography is not simply a matter of degree but a radical opposition'. Such a distinction between image and narrative sequence has its precursor in Gotthold Ephraim Lessing's differentiation, in 1766, between 'arts of space' and 'arts of time'. Lessing's dichotomy underwrites the categorical separation of the still and the moving image on the basis of a supposed absolute difference between simultaneity and succession. Film studies and photography studies have developed separately largely on the basis of this assumed opposition – even while, across the same period of time, there has been increasing technological convergence between these supposedly distinct phenomena. It accords with common sense to assign the still image to photography theory and the moving image to film theory. But to equate movement with film and stasis with photography is to confuse the representation with its material support. A film may depict an immobile object even while the film strip itself is moving at 24 frames per second; a photograph may depict a moving object even though the photograph does not move.[33] Writing in 1971 the photographer and filmmaker Hollis Frampton envisaged an 'infinite film' that would consist of a spectrum of possibilities extending

from the stasis of an image resulting from a succession of completely identical frames to the chaos of an image produced by a succession of totally different frames.[34] Mainstream cinema, 'the movies', inhabits only part of this spectrum: that portion where movement – frame to frame, shot to shot, scene to scene – is intelligible, sentence-like. An interest in movement for its own sake may be found in early twenti-eth-century avant-garde film and photography, and in painting under the impact of film and photography. The interest was comparatively short-lived. In the early days of television the BBC filled the gaps between its infrequent programmes with a fixed shot of a windmill on a hillside, sails turning. It became the icon of boredom for an entire nation. It is not movement as such that fascinates most people but purposive movement, movement with causes and consequences. What audiences find most interesting about characters on the screen is not their movements (albeit these have their own, primarily erotic, interest) but their acts. Activity, however, is not necessarily bound to movement. Peter Wollen illustrates this point with reference to a book of photographs by André Kertèsz entitled *On Reading*.[35] Wollen observes that although all the people in the photographs are motionless they are nevertheless doing something. He writes: 'They are not simply static or frozen in place. They are all in the process of reading'; thus, 'We can see that activity is not at all the same thing as movement.'[36] Chris Marker's film *La Jetée* is perhaps the most wide-ly commented on example of a work that disjoins action from move-ment and contradicts the idea of a fundamental opposition between film and photography (see 6, 'Marker Marked').[37] In an unreleased version of this film the initial title and credits appear over moving images of the pier at Orly airport. In the definitive, released, version they appear over a sequence of stills. Some of the images in the film are shot with a still camera, others are derived from film footage. *La Jetée* rejects the 'radical opposition' between film and photography in favour of a choice between equally available options. It moreover demonstrates that a distinction between film and photography based on the difference between simultaneity and succession is founded on

a misrecognition. Although a photographic exposure may be made 'in the blink of an eye', the experience of looking at the resulting image belongs to the subjective register of *durée* rather than to the mechanical abstraction of the 'instant' in which the image was recorded on film.[38]

The disjunction of activity and movement was recognized early in the history of painting. Between the sixteenth and eighteenth centuries a body of doctrine was assembled in response to the problem of how best to depict a narrative in a painting. With only a single image at his or her disposal, it was agreed that the painter would do best to isolate the *peripeteia* – that instant in the story when all hangs in the balance. The viewer might then feel, for example, the moral weight of a momentous decision in the very instant that the scales of history tipped. It went without question that the viewer already knew the story. The space in and between images is crossed with the always already *known* of stories. As Barthes writes, 'narrative is present in myth, legend, fable, tale, novella, epic, history, tragedy, drama, comedy, mime, painting . . . stained glass windows, cinema, comics, news item, conversation. . . . narrative is present in every age, in every place, in every society; narrative is international, transhistorical, transcultural: it is simply there, like life itself.'[39] But our ready capacity to insert image fragments into the narratives to which they may be called is not due to the mere fact that narrative is everywhere. It is due to the fact that narratives, like the languages in which they are composed, are *articulated*. In his widely influential book *Morphology of the Folktale*, first published in 1928, Vladimir Propp reduces the multiplicity of fairy tales he analyses to a finite number of basic 'functions' that in combination make up the variously individual stories. In an essay of 1969 Barthes argues that these functions that in turn be decomposed into smaller units: for example, 'it is because I can spontaneously subsume various actions such as *leaving, travelling, arriving* . . . under the general name *Journey*, that the sequence assumes consistency.'[40] In his book of 1970, *s/z*, Barthes coins the expression 'proairetic sequence' for such series, taking the term *proairesis* from

Aristotle who uses it to name 'the human faculty of deliberating in advance the result of an action, of *choosing* (this is the etymological meaning) between the two terms of an alternative the one which will be realized'.[41] The '*peripateian* moment' of academic history painting might consequently be considered a 'freeze frame' from a proairetic sequence, an image from an implied narrative series. But the temporality of arrest in history painting is rarely so straightforward, and may as readily imply a sequence-image as an image sequence. For example, Norman Bryson observes that Poussin's painting *Israelites Gathering Manna in the Desert* juxtaposes within the same image 'scenes of misery from the time before the manna was found, with scenes . . . from the time after its discovery'[42] History painting routinely exhibits this characteristic attribute of the sequence-image: the folding of the diachronic into the synchronic.

Barthes' idea of proairetic codes allows us in principle to trace the lines of latent narratives underlying manifest fragments – much as an archaeologist might envisage the form of an ancient dwelling, and a whole way of life associated with it, from the indications of some pottery shards. But what would it mean to see the fragmentary environment not (or not only) in terms of an 'already read' determinate content, but in such a way that the fragmentary nature of the experience is retained? In recollecting his reverie on the banquette Barthes speaks of the 'spacing' of the elements that penetrate from outside. The word he uses, *échelonnement*, may refer to either a spatial or a temporal context; what is essential is the idea of discontinuity, of absences, of gaps. Considering the course of painting after Cézanne, particularly Cubist painting, Maurice Merleau-Ponty writes:

> The different parts of their painting are viewed from different points of view, giving . . . the feeling of a world where two objects are never seen simultaneously, where, between parts of space, there is always interposed the duration [*durée*] necessary to carry our regard from one to the other, where being . . . appears or transpires across time.[43]

In this sense, narrative is normally the equivalent of perspective: bridging gaps, it smooths discontinuities into a continuum – much as 'secondary revision', in Freud's account of the dream-work, makes a drama out of a picture-puzzle. In his reply to *Cahiers du Cinéma* Barthes drew an intransigent line between 'image' and 'image sequence' on the basis of their susceptibility to linguistic analysis. Barthes' student Christian Metz most exhaustively demonstrated the extent to which linguistic models may be applied in the theoretical description of narrative films, and I believe that Barthes was simply wrong in asserting that linguistically derived modes of analysis cannot be applied to photographs. But Barthes on the banquette remarked on a field of experience in which a different kind of object may be discerned: 'lexical' but 'sporadic' and truly 'outside linguistics'. As this object – the *sequence-image* – is neither image nor image sequence, it belongs neither to film nor to photography theory as currently defined. Indeed it may be doubted whether it can ever be fully a *theoretical* object, at least so long as theory remains an affair of language. The early Wittgenstein famously concluded, on the last page of the *Tractatus*, 'Whereof one cannot speak, thereof one must be silent.'[44] To which his colleague and translator Frank Ramsey added: 'What we can't say we can't say, and we can't whistle it either.' The belief that much of what cannot be said may nevertheless be whistled is foundational not only to music but to the visual arts. To write about the sequence-image is to confront a version of the choice that Barthes presented on the last page of *Mythologies*:

> this choice can bear only upon two equally excessive methods: either posit a real [*réel*] entirely permeable to history, and ideologise; or, conversely, posit a real that is *finally* impenetrable, irreducible, and, in this case, poeticise. . . . we ceaselessly drift between the object and its demystification, powerless to render its totality: for if we penetrate the object, we liberate it but we destroy it; and if we leave it its weight, we respect it but we restore it still mystified.[45]

In the chapters that follow I am undecided in my exercise of this choice. Sometimes I feel that the only adequate way to approach the sequence-image is to write in such a way as to evoke its associative structure, which is to say 'poeticise'. At other times I feel compelled to invoke what psychoanalytic theory knows about the *determination* of this object, and so 'ideologise'. I am comforted that Francesco Casetti concludes his review of 50 years of film theory with the observation that it 'can no longer offer unequivocal, direct, definitive answers. Its only chance is to offer a research network that both pursues and envelops the object under study. Theory must be a fragmented and dispersed form of knowledge, knowledge about cinema as well as beyond cinema.'[46] It is in this perspective that the following chapters elaborate on some of the salient topics of this introduction: 'topics' both in the sense of themes to be written about, and in the sense of sites in a particular topography – that of the cinematic heterotopia. The chapters represent 'samples' from this irreducibly heterogeneous field: 'Barthes' Discretion' departs from Barthes' essay 'En sortant du cinéma' to open the theatrical setting of cinema to its own outside; 'Jenni's Room' raises an issue of interpretation in the 'limit case' of a potentially lifelong film as 'truth at one frame per three minutes'; 'The Remembered Film' considers mechanisms at play in the association in memory of fragments from otherwise unrelated films; 'Mies in Maurelia' describes the 'catalytic' role of an evanescent image from a documentary film recollected in an architectural setting; 'Marker Marked' explores the opposition between 'still' and 'moving' in Chris Marker's film *La Jetée* from the basis of the question: 'What does it mean to be marked by an image?'

2 Barthes' Discretion

Film has finally attracted its own Muse. Her name is Insomnia.
Hollis Frampton[1]

That which love worst endures, discretion.
John Donne[2]

In *La Paresse*, Jean-Luc Godard's fifteen-minute contribution to the
film *Sept péchés capitaux*,[3] Eddie Constantine plays an actor in B-movies
who turns down an offer of sex from an ambitious young starlet. The
reason he refuses, he tells her, is that he cannot bear the thought of –
afterwards – having to get dressed all over again. In a note on this
short film, Alain Bergala observes:

> Eddie Constantine marvellously embodies that very special
> state given by an immense lassitude, an apparent inertia which
> is in fact a state of great porosity to the strangeness of the
> world, a mixture of torpor, of loss of reality and of a somewhat
> hallucinatory vivacity of sensations. . . . Godard speaks to us
> of this very special way of being in the world, on the edge of
> sleep . . .[4]

That such a somnolently receptive attitude might be the basic con-
dition of all cinematic spectatorship was first suggested in a special
issue of the journal *Communications* devoted to 'Psychoanalysis and

Cinema'. Published in 1975, the issue has five photograms on its cover – arranged vertically, in the manner of a film-strip. The top and bottom frames are both from the same film, *The Cabinet of Dr Caligari*. They show the face of the somnambulist Cesare – first with eyes staring open, then with eyes closed. To look quickly from one frame to the other produces a rudimentary animation – Cesare appears to blink. The image of the cinema audience as waking somnambulists, blinking as they emerge from the auditorium into the light, may be found in more than one of the essays in this issue of *Communications*. Christian Metz, for example, writes that 'spectators, on leaving, brutally expelled from the black interior of the cinema into the vivid and unkind light of the lobby, sometimes have the bewildered face . . . of people just waking up. Leaving the cinema is a bit like getting out of bed: not always easy . . .'.[5] Metz notes that the subject who has fallen prey to the 'filmic state', feels 'as if numb' [*engourdi*]. Roland Barthes describes his own feelings 'On leaving the cinema'[6] in much the same terms. He feels: 'a little numb [*engourdi*], a little awkward, chilly, in brief sleepy: *he is sleepy*, that's what he thinks; his body has become something soporific, soft, peaceful: limp as a sleeping cat.'[7]

Barthes' short essay of 1975, 'En sortant du cinéma', may be read as a reprise of his essay of 1973, 'Diderot, Brecht, Eisenstein'.[8] The theme of 'representation' – defined as a structure that guarantees the imaginary capture of a subject by an object – is central to both essays, but is developed differently in each. The earlier essay points to an irresolvable problem in any politically inspired attempt to free the spectator from the grasp of the spectacle *from within the spectacle itself*. Barthes acknowledges that the 'tableau', the 'epic scene', the 'shot' – all work against narrative *mimesis* and identification. Framing the mutely eloquent 'social gest', the tableau may produce the effect of 'distanciation' (*Verfremdung*). The spell is broken, the spectator's eyes are opened – but onto what? 'In the long run', Barthes observes, 'it is the Law of the Party which cuts out the epic scene, the filmic shot; it is this Law which looks, frames, enunciates.'[9] It takes a 'fetishist subject', Barthes writes, to 'cut out the tableau' from the diagesis. He

cites a lengthy passage from Diderot's defence of the tableau, which concludes: 'a painting made up of a large number of figures thrown at random on to the canvas . . . no more deserves to be called a *true composition* than scattered studies of legs, nose and eyes . . . deserve to be called a *portrait* or even a *human figure.*' Barthes comments that it is this transcendental *figure*, 'which receives the full fetishistic load'.[10] But Diderot's unification of a 'body in pieces' within the bounds of a 'figure' might as well be assimilated to Lacan's account of the mirror stage as to Freud's account of fetishism. In his later paper, Barthes writes: 'I stick my nose, to the point of squashing it, to the mirror of the screen, to this imaginary "other" with whom I narcissistically identify myself.'[11] To pass from Barthes' earlier paper to the later one is to watch a scene of fetishistic fascination cede prominence to one of narcissistic identification – but as if in a filmic cross-dissolve, where neither scene may yet be clearly distinguished from the other. What remains in focus, in both the essays of 1973 and 1975, is the question of the autonomy of the subject of civil society in modern, media-saturated, democracies. But whereas Barthes' essay 'Diderot, Brecht, Eisenstein' explicitly takes up the question of how to awaken the hypnotized subject of this society of the spectacle, 'En sortant du cinéma' implicitly raises the question of whether somnolence itself may not be the spectator's best defence before the spectacle of the Law.

As much as he may go to the cinema to see this or that movie, Barthes confesses, he also goes for the darkness of the auditorium. The necessary precondition for the projection of a film is also 'the colour of a diffuse eroticism'. Barthes remarks on the postures of the spectators in the darkness, often with their coats or legs draped over the seat in front of them, their bodies sliding down into their seats as if they were in bed. For Barthes, such attitudes of idle 'availability' represent what he calls the 'modern eroticism' peculiar to the big city. He notes how the light from the projector, in piercing the darkness, not only provides a keyhole for the spectator's eye, but also turns that same spectator into an *object* of specular fascination, as the beam 'illuminates – from the back, from an angle – a head of hair, a face'. Just as

Metz speaks of 'l'état filmique' of the spectator, so Barthes posits a fundamental 'situation de cinéma'. But whereas Metz speaks of this torpidly receptive state as produced by a visit to the cinema, for Barthes it is a precondition of the visit. He writes:

> the darkness of the movie theatre is prefigured by the 'twilight reverie' (preliminary to hypnosis, according to Breuer–Freud) which precedes this darkness and leads the subject, from street to street, from poster to poster, finally to engulf him in a dark cube, anonymous, indifferent, where must be produced this festival of affects we call a film.[12]

While watching the film, he writes: 'It is necessary for me to be in the story (the *vraisemblable* requires it), but it is also necessary for me to be *elsewhere*: an imaginary slightly unstuck (*décollé*), that is what, as a scrupulous fetishist . . . I require of the film and of the situation where I go to look for it.'[13] Barthes unsticks himself from the screen by allowing his attention to peel away, to 'take off', to 'get high'.[14] His act of ideological resistance – for all that it proceeds from an ethical attitude – takes the route of pleasure, rather than denial. He responds to the fetishistic and ideologically suspect visual pleasure of narrative cinema not by resisting the perversion, but by doubling it. Barthes suggests a culturally dissident way of going to the cinema other than 'armed by the discourse of counter-ideology'; it is:

> in allowing oneself to be fascinated two times: by the image and by what surrounds it, as if I had two bodies at the same time: a narcissistic body which looks, lost in the close mirror, and a perverse body, ready to fetishise, not the image, but precisely that which exceeds it: the grain of the sound, the theatre itself, the darkness, the obscure mass of other bodies, the rays of light, the entrance, the exit: in brief, to distance myself, 'unstick', I complicate a 'relation' by a 'situation'.[15]

We leave the movie theatre, Barthes suggests, only to re-enter an *other* cinema, that of civil society. He writes:

> The historical subject, like the spectator in the cinema I am imagining, is also *stuck* to ideological discourse. . . . the Ideological would be at bottom the Imaginary of a time, the Cinema of a society; . . . it even has its photograms: the stereotypes with which it articulates its discourse . . .[16]

These remarks suggest the question: 'what relation, if any, have the means by which Barthes "unsticks" himself from the Imaginary in the movie theatre to the situation of the historical subject glued to the Ideological in society?' It might appear that Barthes 'distracts' himself from the film, by behaving in the cinema much as he might when in the street. In its early history, cinema was more often integrated into everyday urban *flânerie* than it is today. For example, in a chapter appropriately entitled 'Streetwalking around Plato's Cave', Giuliana Bruno has described the peripatetic forms of spectatorship – and their attendant erotics – that accompanied the introduction of cinema to Italy in the closing years of the nineteenth century, most explicit in the practice of projecting films in the open-air of Naple's main shopping arcade.[17] Or again, we may recall the later practice of André Breton and Jacques Vaché, who would visit as many cinemas in Nantes as they could within the space of a single afternoon – entering and leaving with no regard for any narrative development other than that of their own *dérive*. Today, our everyday passage through the 'Cinema' outside the movie theatre takes us through television, advertising and glossy magazines. These are the arts that are today appreciated – like architecture, in Benjamin's description – 'in a state of distraction'. However, the distraction that typically accompanies an evening's television viewing – answering telephone calls, fixing drinks, chatting, 'zapping', flipping through newspapers and magazines, and so on – has nothing to do with the distance Barthes finds in the movie theatre. When watching television, Barthes remarks, anonymity is lost, the

surrounding bodies are too few. Worst of all, 'the darkness is erased,' and we are, '*condemned* to the Family'. As a consequence of all this, 'the *eroticism* of the place is foreclosed'.[18] In an essay about a Paris dance-hall, Barthes writes:

> I admit to being incapable of interesting myself in the beauty of a place, if there are no people in it . . .; and reciprocally, to discover the interest of a face, a silhouette, an item of dress, to savour an encounter, I need the place of this discovery, also, to have its interest and its savour.[19]

This simultaneity of fascination by both people and place, he remarks later, amounts to: 'that which one calls Festival, and which is quite different from Distraction'.[20] We may recall that Barthes refers to the film as a 'festival of affects'. He goes to the cinema, he says, only in the evening. The city at night is a form of organization of general darkness, and Barthes sees the darkness of the cinema as a particular form of organization of the darkness of the city at large. The movie auditorium, he says, condenses the 'modern eroticism' of the big city. It is as if what Barthes calls 'the eroticism of the place' were a modern equivalent of the eighteenth-century *genius loci*, the 'genius of the place'. Like the attendant Spirit, the erotic effect may be unpredictably fleeting in its appearances. In *Le Plaisir du texte*, Barthes writes: 'it is intermittence, as psychoanalysis has so well stated, which is erotic: . . . the staging of an appearance-disappearance.'[21] The eroticism that may accompany what Barthes calls 'the Cinema of a society', like the 'dancing ray of the projector' of which he speaks, *flickers*. Baudelaire chose precisely this term to describe the pleasures of the crowded city street, speaking of 'the flickering grace of all the elements of life'.[22] The photograms of Barthes' biphasic Cinema – his festival for two bodies, narcissistic and perverse – appear abruptly, detaching themselves from the phenomenal flux in the manner of the *fragment* of which he speaks in *Roland Barthes par Roland Barthes* – in, 'a yawning [*bâillement*] of desire'.[23] If desire 'yawns', it may have more than a

little to do with the alert torpidity of the somnambulist, or of someone on their way home to bed.

In a passage in *Soirées de Paris*, Barthes recounts flickering chance encounters during his walk home at the end of an evening spent in cafés – as if reversing the itinerary, 'from street to street, from poster to poster', he describes as leading him to the cinema. In the rue Vavin he crosses the path of a beautiful and elegant young woman, who trails behind her 'a delicate scent of muguet'. On a column in the rue Guynemer he comes across a film poster, with the names of two actresses – Jane Birkin and Catherine Spaak – printed in huge letters (as if, Barthes remarks, the names alone were 'incontestable bait'). In front of a house in the rue de Vaugirard there appears 'an attractive silhouette of a boy'.[24] The film poster clearly may represent what Barthes calls a 'photogram' of the Ideological. Along with other forms of publicity, film posters mainly show stereotypical individuals and objects, in stereotypical relations and situations. In *Mythologies*, and subsequent texts, Barthes gave us the means to demystify and dismantle such 'rhetoric of the image' in terms of counter-ideological analyses – Marxism, semiology. In 'En sortant du cinéma', he uses a Lacanian vocabulary. In these terms, what constitutes the Imaginary exceeds what an ordinary taxonomy of objects of daily use may classify as 'images'. The 'beautiful woman' and the 'attractive boy' not only have their counterparts in actual film posters, they may serve as living photograms – ideologemes – in Barthes' Cinema of society. In 'En sortant du cinéma', Barthes asks, in passing: 'Do we not have a dual relation to the common place [*lieu commun*]: narcissistic and maternal?'[25] The woman trails behind her 'a scent of muguet'. In France, by long tradition, sprigs of muguet – a small, white, bell-shaped flower – are sold on the streets on the first day of May. Small children – raised in their mother's shadow – learn the division of common time through such traditions. This woman who casts the shadow of time itself might be assimilated to the maternal side of that 'dual relation' that Barthes invokes. The 'attractive silhouette' of the boy – whose fugitive character elicits what Benjamin called 'love at last

sight' (prompted by Baudelaire's verses *A une passante*) – might be assimilated to the other, narcissistic, side.

Another evening in Paris, Barthes follows a route that will eventually lead to the 'dark cube' of a movie theatre. He first visits a gay bath house, then moves on to what seems to be some sort of brothel. Here, Barthes notes, 'about to leave is a beautiful Moroccan who would really like to hook me [*m'accrocher*] and gives me a long look; he will wait in the dining room until I come down again, seems disappointed that I don't take him right away (vague *rendez-vous* for the following day). I leave feeling light, physically good . . .'.[26] The image of Barthes on the stair, exchanging glances with the 'beautiful Moroccan', reminds me of another image. Bergala's note on *La Paresse* is part of a Godard filmography in a special issue of *Cahiers du Cinéma*. A band of photograms runs horizontally along the bottom of each page of the filmography – less like a film strip than a comic strip, or *photo roman*. One of the images is from *La Paresse*. Eddie Constantine appears to have just descended a carpeted staircase, which winds up and out of frame behind him. He is immaculately dressed in suit and tie, and is wearing a hat. He is looking at the starlet – who is standing close by him, dressed only in her underwear. Barthes traces Brecht's idea of the 'social gest' to Diderot's concept of tableau. The tableau has a history prior to Diderot. In the mid-sixteenth century, Humanist scholars gave advice to painters in which two ideas were essential: first, the painter should depict human action in its morally most exemplary forms; secondly, as the 'history painter' could show only a single moment from a moral fable, then that moment should be the *peripateia* – the 'decisive moment' when all hangs in the balance.[27] The images of, respectively, Barthes and Constantine on the stair both have something about them of a motif that appears throughout the history of Western European painting: 'Hercules at the Crossroads'. I ask to be excused comment on what, to a 'counter-ideological discourse', is most obvious in both of these modern *mises-en-scènes* of choice – the inequitable distribution of material authority across the lines of, respectively, race and gender. My particular interest here is

in what this image condenses of Bergala's description of Godard's film, and what, in turn, this description condenses of all of what Barthes has to say about 'la situation de cinéma'. The woman in the diagesis is making a spectacle of herself; in French, one might say, 'elle fait son cinéma'. Constantine on the stair, much like Barthes on the stair, responds with, to repeat Bergala's words, 'an apparent inertia which is in fact a state of great porosity to the strangeness of the world, a mixture of torpor, of loss of reality and a somewhat hallucinatory vivacity of sensations'.

The expression 'hallucinatory vivacity' may remind us of Barthes' description of the photograph. The photograph, he says, represents 'an anthropologically new object', in that it constitutes 'a new form of hallucination: false at the level of perception, true at the level of time'.[28] The film, on the other hand, is 'always the precise opposite of an hallucination; it is simply an illusion . . .'.[29] The film 'can present the cultural signs of madness, [but] is never mad by nature'.[30] To the contrary, the photograph is an authentically 'mad image, rubbed by the real'.[31] Nevertheless, the abrasion of image against real, which Barthes finds and values in photography, is at least structurally similar to his readiness, when in the cinema, 'to be fascinated *two times*: by the image and by what surrounds it'. In *Roland Barthes par Roland Barthes*, he writes:

> The dream displeases me because one is entirely absorbed by it: the dream is *monological*; and the fantasy pleases me because it remains concomitant to the consciousness of reality (that of the place where I am); thus is created a double space, dislocated, spaced out . . .[32]

These men on the stair are not sleepwalkers, but they are 'spaced out'. In 'En sortant du cinéma', it is as if Barthes is urging a practice of spectatorship that will pull the filmic experience towards the side of fantasy, and away from the shore of the dream. Barthes' inclination to phenomenology leads him to seek mutually exclusive 'essences' of

film and photography. But such oppositions fade as he steers closer to semiology and psychoanalysis. Barthes himself admits as much, even in one of his more 'phenomenological' texts. On the first page of *La Chambre claire*, he writes: 'I declared that I liked Photography *against* the cinema – from which, however, I never managed to separate it.'[33] Here then, is another site of abrasion: where photography touches cinema. Barthes' well-known interest in the film-still is often mentioned to exemplify his preference for the photograph over the film. The 'photogram', however, is strictly *neither* photograph *nor* film. It is the material trace of that moment of arrest that establishes a space *between* the photograph *and* the film. In terms of Lacan's discussion of the gaze, to which Barthes explicitly gestures in 'En sortant du cinéma', this time of arrest is that of the 'lure'.

The filmic image, says Barthes, is: 'A *lure*'. He adds: 'This word must be understood in the analytical sense.'[34] Lacan uses the word *leurre* with the full range of meanings it takes in French: 'lure', 'bait' and 'decoy'; 'allurement' and 'enticement'; 'trap', 'delusion' and 'deceit'. The analytical sense that Lacan brings to it comes most specifically from what he makes of Roger Caillois' remarks on the 'three functions of mimicry'.[35] In the animal and insect behaviours named by Caillois as *travesty*, *camouflage* and *intimidation*, Lacan says: 'the being gives of itself, or it receives from the other, something which is mask, double, envelope, detached skin, detached to cover the frame of a shield'.[36] The frame from *La Paresse* depicts just such a meeting of masks – as beautiful as the chance encounter, on a staircase, of some undergarments with a business suit. 'Without any doubt', Lacan remarks, 'it is by the intermediary of masks that the masculine, the feminine, meet in the most pointed, the most ardent, way.'[37] However, Lacan notes a difference between human behaviour and the behaviours described by Caillois:

> Only the subject – the human subject, the subject of desire . . . is not, unlike the animal, entirely held by this imaginary capture. He takes his bearings in it [*Il s'y repère*]. How? To the

extent that he isolates the function of the screen, and plays with it. Man, in effect, knows how to play with the mask, as being that beyond which there is the gaze. The screen is here the place of mediation.[38]

Christian Vincent's film *La Discrète* is a story of seduction and betrayal set in modern-day Paris.[39] It takes its title, however, from a practice of the seventeenth century. Fashionable women of that period would wear a 'beauty spot' – usually a dot of black taffeta – on their face. When worn on the forehead it was called a *majestueuse*, placed by the eye it was a *passionnée*, by the lips a *galante* and on the chin a *discrète*. In eighteenth-century Venice the *moretta* was one of only two masks worn at carnival time, and it was worn only by women. The *moretta* was held in position by means of a button gripped between the teeth – in order to speak, the woman had to unmask, quite literally to 'reveal herself'. Both practices exemplify (in one case, quite literally) a play with the mask in the field of the gaze. As in all play – productive of spacing, difference – meaning is created. A fascination beyond words is at the same time a potentially garrulous semiotic system. For the human animal, the lure is a place of passage between Imaginary and Symbolic, between the drive and the contractual regulation of sexuality. What flickers on the screen of the lure is the dance of Desire and the Law. Barthes emphasizes that the filmic image, which so often stages the scene of lure, is itself a lure. However, so, potentially, is any other image in the 'Cinema of society'. Barthes himself recognizes this in the very terms of his exasperation at the film poster he comes across in the rue Guynemer, the actresses' names printed large: 'as if they were incontestable bait' (*appâts*). The look given by the actresses emerges from within an image-product of a visual cultural institution – here, the cinema – of the Cinema of society. That is to say, the look emerges from within the *gaze*. Amongst the various functions of the gaze is the *subjection* of what Barthes calls the 'historical subject'. Lacan gives the example of the mural paintings that adorn the great hall of the Doge's Palace in Venice:

Who comes to these places? Those who form that which Retz calls *the people*. And what do the people see in these vast compositions? The gaze of those persons who – when they are not there, they the people – deliberate in this hall. Behind the painting, it is their gaze which is there.[40]

Today, the environment of images from what we call 'the media' has taken the place and the function of those murals in the Doge's Palace. Lacan does not mention it, but the paintings – like the products of the media today – would also have been an object of wonder and delight, of fascination, for those subjected to the authority of those who commissioned the images. The long history of the multiple forms of decoration and pageant in society demonstrates the inseparability of power from visible display: the element of hypnotic fascination in voluntary submission. However, such means of control are unstable, and the history of authority is also one of struggle for mastery of the 'twilight reverie'.

Lassitude, inertia, torpor; a body become soporific, soft, limp; a loss of reality, a porosity to the strangeness of the world, a hallucinatory vivacity of sensations. A 'very special way of being in the world', known for centuries of Western Christianity as the condition of *acedia* – a state of mortal sin. In his book on the concept of *acedia* in medieval thought and literature,[41] Siegfried Wenzel traces the notion of the 'sin of sloth' to the fourth Christian century, and the milieu of Egyptian desert monks who lived near Alexandria. For these monks, Acedia was the name of a demon with whom they frequently fought. A stealthy drowsiness would announce the arrival of the demon. There would then follow an assault of impressions, thoughts and feelings that could overwhelm devotional duty. Monks became melancholy; they found it difficult to remain in their cells and would wander out in search of the secular world they had renounced. By the twelfth century, *acedia* – 'Sloth' – was firmly established as one of the 'seven deadly sins'. Its most 'modern' description, however, was given at the inception of the concept. Wenzel writes that, in the early Christian

moral theology of Clement of Alexandria, *acedia* was judged to be the product of 'affections of the irrational part of man's soul, which originate in sense impressions or in memory and are often accompanied by pleasure'. In the soporific state of *acedia*, 'reason is . . . subjected to the ebb and flow of affections, which tyrannize it and keep it in a state of turmoil – the master has become a slave.'[42] *Acedia*, then, threatens the hierarchical order of things: the theocentric order of Christianity, certainly, but also the secular world order of Western capitalism that would succeed it. The religious education of the industrial proletariat continued to stress that 'the devil finds work for idle hands'. Common soldiers in imperialist armies, when neither fighting nor training, were put to such work as whitewashing lumps of coal. Fundamental to the instrumental logic of slave ownership was the category of the 'lazy slave'; in the logic of the colonialist it was the 'lazy native'. Clearly, the threat of lassitude was less to production than to authority – whether that of God or Mammon. Lassitude can in fact be highly productive, but what it produces is insubordination and syndicalism, mutinies and revolutions. At this point, however, we may no longer distinguish between the corrosive consequences of lassitude and the products of a counter-ideological reason honed through leisure.

Until about the twelfth century, *acedia* was considered to be mainly a monastic vice, one that attacked those devoted to the contemplative life.[43] In *Soirées de Paris*, Barthes confesses to his difficulty in remaining in his cell: 'Always this difficulty in working in the afternoon', Barthes writes, 'I went out around six-thirty, looking for adventure.'[44] It would not have surprised a desert monk to learn that Barthes wound up soliciting a male prostitute on the rue de Rennes, giving him money on the promise of a *rendez-vous* an hour later. 'Naturally', Barthes writes, 'he wasn't there'. Barthes acknowledges how barely credible his action must seem, in exchanging money for such a promise. But he also recognizes that, whether or not he had gone to bed with this man, 'at eight o'clock I would have found myself again at the same point in my life; and, as the simple contact of the eyes, of the promise, eroticises me, it is for this *jouissance* that I had paid.'[45] In this particular

sector of the libidinal economy, sexual tension is perversely spent in the exchange not only of promises but of temporal location – here coined in a grammatical tense, the future anterior: 'I shall have had'. Constantine, spaced out, refuses sex with the starlet because he speaks to her from a different time: from the aftermath of the afterglow. *Acedia* is a complex vice. The fourth-century treatises on spiritual life that established the concept of *acedia* also inaugurated the practice, followed in medieval handbooks, of identifying the 'daughters' to whom this or that of the seven capital sins had given birth. Disobedience was only one of the daughters of *acedia*; amongst the many others was Deferment.

Metz refers to the 'novelistic film' as 'a mill of images and sounds which overfeed our zones of shadow and irresponsibility'.[46] Barthes defers feeding – like a recalcitrant infant who turns from the breast in search of adjacent pleasures; even, or especially, those 'not good for it'. He asks: 'could there be, in the cinema itself (and in taking the word in its etymological profile), a possible *jouissance* of *discretion*?'[47] In exercising his discretion, Barthes is at the same time *at* the discretion of something else. His presence in the cinema is *impulsive*. In *Le Plaisir du texte*, he speaks of 'that moment when my body goes to follow its own ideas – for my body does not have the same ideas as I do.'[48] The pressures of a 'twilight reverie' impel Barthes 'from street to street, from poster to poster', to immerse himself in darkness. Freud spoke of 'somnambulistic certainty' to characterize the unerring confidence with which, under certain circumstances, a long-lost object is found.[49] All that is certain in our compulsion to repeat, however, is that the object will elude us. ('Naturally', Barthes writes, having kept the *rendez-vous*, 'he wasn't there'.) As to the source of our need to *keep* keeping, in Lacan's words, 'an appointment . . . with a real that escapes us',[50] we are all in the dark. Clement of Alexandria found *acedia* to be the product of 'affections of the irrational part of man's soul, which originate in sense impressions or in memory . . . often accompanied by pleasure'. This psychoanalytic judgement *avant la lettre* suggests that 'this special way of being in the world, on the edge of sleep'

steers us closer to the shores of that 'other locality' where Freud first took his bearings: 'another space, another scene, *the between perception and consciousness.*'[51] Between the spectator totally enthralled by the narrative, and the critic who sits analysing shots, there is a continuum of degrees of alertness. Barthes, however, sliding down into his seat, adopts a posture towards the film that cannot be assigned to a simple position on a scale between enthralment and vigilance. 'I am hypnotized by a distance', he writes, 'and this distance is not critical (intellectual); it is, if one can say this, an amorous distance.' A *jouissance* of discretion. A pleasure in differences, distances. A tactful delight in heterogeneity: the 'flickering grace of all the elements of life' that Baudelaire found on the streets of Paris, now revealed by the flickering light of the projector in the auditorium. The café-frequenting spectator's glass of Kir, and dish of olives, have given way to Coca-Cola and buttered pop-corn, but the society is no less utopian for that. In American cities, where 'street life' so often gives way to 'street death', the citizen is almost certainly safer in the movie theatre than at home, at work or in prison. In a world riven by violent factional and fractional conflict, the cinema is peaceful. The cinema audience – a totally aleatory conglomeration of alterities – sleeps together in a space of finely judged proximities, a *touching* space.

On leaving the cinema, the Cinema of society we re-enter today is a *global* cinema, where cultural and ideological differences come together in intimate electronic proximity. In this cinema, also, the image is a lure. Flickering on the hook is the alternative the mirror relation presents: narcissistic identification or aggressive rivalry. Here also, Barthes seems to suggest, we may defer taking the bait – but not in order to calculate a fine scale of 'correct distances' between fusion and abjection. The distance that hypnotizes him, Barthes says, is not intellectual but 'amorous'. The territory of this distance is claimed in the name of Lassitude. Exercising a somnolent discretion, from within a state of great porosity to the strangeness of the world, Barthes embraces that daughter of *acedia* whom we can only name – in the full sense of the word – *Dissipation.*

3 Jenni's Room: Exhibitionism and Solitude

In James Baldwin's novel *Giovanni's Room*, Giovanni lives in a ground-floor room that looks onto a public courtyard.[1] He does not enjoy his room with a view. He paints over the windowpanes with liquid polish to hide himself from passers-by. Readers of Baldwin's novel may easily believe that such behaviour might occur in real life. Giovanni's obscuring gesture seems transparent to our understanding, because most of us value our personal privacy. In this respect the behaviour of Baldwin's fictional character may seem more plausible to us than that of Jennifer Ringley, a real person whose conduct seems barely credible. By means of a camera connected to the World Wide Web she deliberately exposes the interior of her room to the eyes of strangers. At any time of day or night anyone who can log onto the Web may look into Jenni's room.

It was in 1996, on the eve of her 21st birthday, that Jennifer Ringley first attached a video camera to her computer and began to upload images of her college dormitory room to the Internet.[2] Those who visited Ringley's 'JenniCam' homepage in its inaugural year, at www.boudoir.org, could read her answers to some 'frequently asked questions' about these images:

> *What can I expect to see on the JenniCam?*
> Anything I may be doing in my dorm room – reading, writing e-mail . . . , watching TV, playing with my hedgehog Spree, rearranging my room, doing aerobics, just about anything. Since my dorm room is my 'house', I do anything in here that

any person would do in the whole of their house.

Do you censor the JenniCam?

Nope – I never know when the camera is going to take the picture so I have no time to prepare, and I never feel a need to hide anything going on anyway.

Do you ever stage what we see?

I occasionally do 'shows' which are more or less staged, . . . it's nice to be able to acknowledge the camera now and again. But except for these quite obvious shows, everything else is just *moi au naturel*.

Why are you giving up your privacy like this?

. . . I don't feel I'm giving up my privacy. Just because people can see me doesn't mean it affects me. I'm still alone in my room, no matter what.

You're naked sometimes, is this pornography?

That's for the viewer to decide.[3]

Implicit in the questions that Jennifer Ringley chooses to answer is the charge that she is an exhibitionist. Media coverage has tended to assume the charge as proven. The first of many newspaper articles about Jennifer Ringley, in the *Philadelphia Inquirer*, opens with the observation: 'In another time, before the Internet, Ringley might have remained a gifted . . . student . . . with a *latent* exhibitionist streak'. The article goes on to quote a psychology professor who describes Ringley as 'not the first . . . exhibitionist on the Net'.[4] A later article about Ringley, in *USA Today*, reports: 'Peter Crabb, psychology professor at Pennsylvania State University, . . . has studied camcorders' effects on behaviour and [asks] "Do we want to be turned into a society of exhibitionists?"'[5] But the writer of the *Philadelphia Inquirer* article does not explain how the Internet is supposed to have brought out Jennifer Ringley's otherwise 'latent' exhibitionist tendencies. Nor does Professor Crabb explain how exposure to a camcorder may make an exhibitionist of any one of us. Nor do the journalists and psychology professors say how, in defining Ringley as an exhibitionist, they would

distinguish her behaviour from that of the man who compulsively exposes his penis in the street. For it is clear that the exhibitionism at issue is not just any kind of conspicuous public behaviour. What is at issue is Ringley's supposed sexual exhibitionism.

The use of the word 'exhibitionist' in a sexual sense is one that ordinary language has taken from psychiatry and psychoanalysis. In Freud's view exhibitionism derives from voyeurism.[6] The small child first looks at parts of his or her own body associated with sexual pleasure. The child later develops a curiosity about corresponding sites on the bodies of others. He or she then identifies with the look that the other gives, and offers his or her body to this other look. In effect, the exhibitionist proposes a childish exchange: 'I'll show you mine if you'll show me yours.' At the time Jennifer Ringley acquired her QuickCam, real-time video exchanges on the Internet were already possible by means of a freely available program called *CU-SeeMe*.[7] Ringley could have used this program but she did not. She has shown no interest in seeing those by whom she is seen. Medical psychiatry before Freud was a science of appearances. Jean-Martin Charcot, with whom Freud briefly studied, commissioned a volume of photographs depicting the bodily postures adopted by his hysterical patients at the Salpetrière hospital in Paris. He hoped that the images would provide doctors with a means of diagnosing mental illnesses. Freud made a radical break with the established medical tradition of diagnosis through observation. Not content to look at his patients, he listened to them. The judgement that Ringley is simply an exhibitionist is based on her observable behaviour. But if we listen to her we may suspect that there is more to her purported 'exhibitionism' than meets the eye.[8] On her graduation from college Ringley's dormitory room disappeared from the Internet, but another room soon appeared in its place. In a radio interview broadcast in the year following her graduation Ringley was asked what had led her to install the camera in her new apartment. She replied: 'I felt lonely without the camera.'[9]

To think of Jennifer Ringley as an exhibitionist is to think of her camera as if it were a window. This view is encouraged by the language

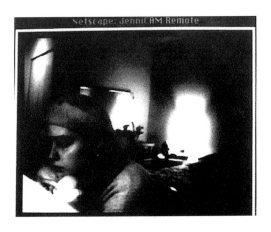

used to describe the computer interface. The terminology used for the Macintosh operating system first spoke of opening 'windows' on the screen. The Microsoft operating system that emulates the Macintosh interface is called Windows. In similar terms the JenniCam homepage offers the visitor the option of opening a 'remote window' on the computer screen. This provides a virtual aperture through which Jenni's room remains constantly visible regardless of what other tasks are performed by the computer. By this means Jenni's room, and at times Jenni herself, becomes a constant companion to the otherwise solitary computer operator. In one of countless images captured by the camera, Jenni sits alone at her computer. In the background of the image is a large mirror. To think of Ringley's camera as a window is to privilege our own point of view. If from this position we judge Ringley to be an exhibitionist we have done no more than acknowledge our own voyeurism. From our side of the screen, the camera is a window. From Ringley's position, her camera is a mirror. Ever since Jacques Lacan's essay on what he calls the 'mirror stage', the idea of the mirror has figured prominently in theoretical writings about the image.[10] I invoke his essay not so much for its direct relevance to Ringley's behaviour but because of a work it has indirectly provoked. In a 1967 essay the English psychoanalyst Donald Winnicott writes: 'Jacques

Lacan's paper "Le Stade du Miroir" . . . has certainly influenced me.
. . . However, Lacan does not think of the mirror in terms of the
mother's face in the way that I wish to do.'[11]

Winnicott was a paediatrician before he became a psychoanalyst.
He never stopped working closely with mothers and children, and
he derived most of his ideas from his close observations of their
interactions. He once said 'There is no such thing as an infant'. Left to
its own devices the human neonate would simply die. The infant is not
a monad, it is part of a symbiotic organism, the other part of which is
the mother. The consequences of the prolonged state of nursling
dependency are at the centre of Lacan's essay. There are nevertheless
substantial differences between Lacan and Winnicott. Lacan's essay
on the mirror stage is concerned with the look that the infant gives.
Winnicott's essay on the 'mirror-role' emphasizes the fundamental
importance of the look that the infant receives. Lacan gives a thorough
consideration to the look received by the subject later in his work. But
he is mainly concerned with the look that comes from outside insofar
as it functions to *subject* the subject, to put the subject 'in its place'.[12]
In Lacanian terms, Lacan's look is on the side of the Symbolic, the side
of the paternal; Winnicott's is on the side of the Imaginary and the
maternal.[13] Winnicott says that when the infant looks at the face of the
mother it sees itself only insofar as the mother recognizes it:

> What does the baby see when he or she looks at the mother's
> face? I am suggesting that, ordinarily, what the baby sees is
> himself or herself. In other words the mother is looking at the
> baby and *what she looks like is related to what she sees there* [italics
> in original].[14]

Does the word 'she' in this sentence refer to the mother or the baby, or
to both at different times? It is not quite clear. Nevertheless Winnicott
affirmatively italicizes the statement. The grammatical confusion
reproduces the structure of the relation described, in which the infant
'takes place' as a projection of its mother's regard.[15] To illustrate some

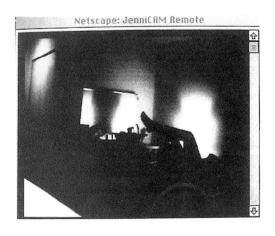

typical consequences for adults of what he is talking about, Winnicott speaks of a patient who tells him she had gone out in the evening to a coffee bar and had been 'fascinated to see the various characters there'. Winnicott notes that his patient has a 'striking appearance'. He asks her if anyone in the coffee bar had looked at *her*. She concedes that some people had looked in her direction but primarily because of the man she had been with. Winnicott remarks that this woman had difficulty in 'being seen in a way that would make her feel she existed'.[16] Another of Winnicott's examples concerns a woman of his acquaintance. To all appearances she has a happy life, but every morning she wakes in a state of 'paralyzing depression'. Her despair only ends (until the *next* morning she wakes up) when she finally comes to 'put on her face'. Only when she puts on her make-up is she able to assume her responsibilities and face the world. The woman, Winnicott observes, 'had to be her own mother'. He writes: 'What is illustrated by this case only exaggerates that which is normal. The exaggeration is of the task of *getting the mirror to notice and approve* [my emphasis].'[17]

Jenni is noticed and approved of. Each day she receives hundreds of new e-mail messages. The *Philadelphia Inquirer* reports that Ringley has been 'sought by Internet suitors around the globe; featured in

Norwegian and Australian magazines'; and 'cheered by British lesbians'.[18] It is perhaps significant that Ringley made her bid for attention on the eve of her 21st birthday and in her final year of college. In Western society the 21st birthday has an exceptional ritual significance; college graduation is charged with a similar meaning. Both mark the transition from a prolonged state of familial dependency to an adult life free of parental supervision. In the words of an old music hall song, 'I've got the key to the door, never been twenty-one before!' Mingled with the jubilation is a certain anxiety as to what might lie beyond the door. Such rites of passage from the protective circle of the family to a potentially hostile outside world may easily revive anxieties, and responses, derived from earlier separations – most particularly, the originative separation from the mother. The infant–mother relation is at the origin of the subject, of space and of objects. In the earliest months of life 'objects' are strictly speaking subjective. The infant has no means of distinguishing between its psychical reality and the external world.[19] Lacan's essay on the mirror stage describes how the infant first forms an idea of its body as distinct from external reality. The infant unifies certain objects within a bounding outline, the newly drawn frontiers of the subject. Other objects – henceforth the 'not me' – are simultaneously exiled to the other side of the border, the outside of the skin.[20] But the unitary self-image formed in the mirror stage is not a snapshot. The distinction between the self and objectively existing things is not achieved 'in the blink of an eye'. It takes time. The piece of blanket or tattered teddy-bear to which the small child clings with a special fervour is, in the expression of Donald Winnicott, a 'transitional object' in that it marks the passage of the infant and small child into that differentiated world in which he or she exists separately from his or her mother.[21] Its function is to assuage the anxiety that accompanies the process of differentiation. The more general concept of transitional *phenomena* is at the foundation of Winnicott's notion of play, a fundamentally important stage of which he calls 'being alone in the presence of someone'.[22] At this stage, he writes:

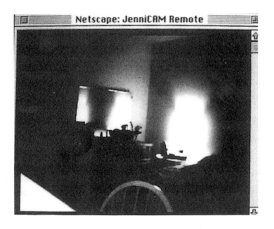

The child is now playing on the basis of the assumption that the person who loves and who is therefore reliable is available and continues to be available when remembered after being forgotten. *This person is felt to reflect back what happens in the playing* [my emphasis].[23]

In his essay, 'The Capacity to be Alone', Winnicott therefore remarks that 'the basis of the capacity to be alone is a paradox; *it is the experience of being alone while someone else is present* [my emphasis]'.[24]

Jennifer Ringley first sets up her 'JenniCam' in her college dormitory room. It is her first room away from home. But although the dorm room is not home, neither is it yet fully the outside world. In Britain, university professors were once legally considered to be *in loco parentis*. American colleges still actively cultivate a familial environment. The dormitory room is a transitional space. It lies between the primitive space of infantile omnipotence under maternal protection and the adult space of civil society. Like the temporal space of adolescence that it prolongs, the dorm room is a space of experimentation and reality testing, a space in which risks are taken.[25] We have probably all seen the behaviour of the small child who prepares to leap from a high place with the cry 'Look at me! Look at me!' The

exhortation is usually directed to its mother, or some adult surrogate. We might regard it as a childish form of exhibitionism. But such behaviour might equally well be understood as a risky experiment hazarded only under the protective maternal gaze.[26] The child will recklessly launch itself into the void, and into its own increasingly risky future, only when it feels its flight securely reflected in its mother's eyes. Ringley says: 'I occasionally do "shows" which are more or less staged.' The *Philadelphia Inquirer* article reports that during the first year she set up the JenniCam, Ringley performed a number of 'shows' in which she dressed in 'garter belts and spike heels'.[27] In a classic US television comedy sketch, the late Gilda Radner becomes a child, alone in her room, who uses her bed as a stage on which she stars in a variety of adult roles. Like the performances that Jenni gives, often from the stage of her own bed, the solitary child's play is performed to an invisible audience, to some person, who is 'felt to reflect back what happens in the playing'. For Winnicott, 'this area of playing is not inner psychic reality. It is outside the individual, but it is not the external world.'[28] What better description could we have of the space of the Internet? Parading around her Web-sited dorm room in spike heels, Jenni is tottering around in her mother's shoes. Under the gaze of her mother she is investigating what it is to be a woman, like her mother. That is to say, she is posing the question of female sexuality. The fledgling subject's sexuality is inaugurated in the space of the family. The infant is seduced into polymorphously perverse sexuality through the ordinary care given by the mother in response to its basic organic functions of feeding and excreting.[29] Under the interdiction of incest this sexuality is destined to be definitively exiled from the familial space. In terms of social geography Jenni's perverse tableau is staged in a place of transition (the dorm room) between home and the outside world, and in an iconography conventionally sited between normal and perverse ('garter belts and spike heels'). In psychical terms her dressing-up act is situated in a transitional space in which what is fantasy and what is reality is not decided. As Winnicott puts it, 'The question is not to be formulated.' On one

particular occasion, however, Jenni's show provoked an e-mail threat of physical violence so extreme that it led her to shut off her camera for a while. 'I hid in my room for three days', said Ringley. 'I was terrified.'[30] Winnicott writes: 'The thing about playing is always the precariousness of the interplay of personal psychical reality and the experience of control of actual objects.'[31]

The threatening e-mail message that Jennifer Ringley received in response to her reality-testing contained the demand that she perform a striptease for the camera. A popular MTV series lays bare the daily lives of a group of 'twenty-something' people sharing an apartment. The programme is called 'The Real World'. The NTSC signal that broadcasts the 'real lives' of these young people provides 29.97 frames of video every second. Jenni's real world is transmitted at the rate of one frame every three minutes. What appears on the computer screen is not a live video image but a sequence of video stills. A woman friend once presented me with a cheap ballpoint pen. Printed on its barrel was a picture of a young woman in a one-piece bathing costume. If the pen were held not in the position for writing but with the sharp end tilted upright, the 'bathing suit' (an opaque liquid) would wipe down to reveal the woman's body. The JenniCam picture updates in a similar way. The present image of Jenni's room abruptly gives way to a black frame. Then the new image is incrementally revealed as it wipes down from the top of the frame, progressively replacing the area of black. There is something of striptease in the way the space is revealed. Then there is the three-minute interval of time before one image gives way to another in which whatever may happen in Jenni's room occurs unseen. There are also the parts of Jenni's domestic space that remain perpetually offscreen. Certainly there is plenty here to provoke the desire to see what is concealed even on occasions when the architect of this scopophilic apparatus is herself absent from the scene.[32] Jenni's onscreen appearances have included not only occasions when she playacts the seductress but also scenes of her having sex with her boyfriend. Many of these images have been scrupulously collected by her self-proclaimed 'fans' and made

publicly available on an 'adult' web site. But such scenes constitute only a very small proportion of Jenni's onscreen life. They represent part of the ordinary private life of almost any woman of Ringley's age. Their absence would have been more remarkable than is their presence.[33]

The person who violently demanded that Jenni perform a striptease seems blind to the fact that Jenni never does anything else. But Jenni plays not simply with the revelation and concealment of parts of her body. More significantly, it is her entire person whose coming and going she controls. Roland Barthes once asked: 'Is not the most erotic portion of a body *where the garment gapes*?' He continues:

> In perversion . . . there are no 'erogenous zones' . . . ; it is intermittence, as psychoanalysis has so rightly stated, which is erotic: the intermittence of skin flashing . . . between two edges (the open-necked shirt, the glove and the sleeve) . . . it is this flash which seduces, or rather: the staging of an appearance-as-disappearance.[34]

Of all the images captured by the JenniCam those that capture Jenni are in the minority. Jennifer Ringley reaffirms the fundamental law of the eroticization of absence. We might also discern the outline of a more primitive scene of coming and going within Ringley's play. In his book, *Beyond the Pleasure Principle* (1920), Freud describes watching his eighteen-month-old grandson repeatedly throw over the edge of his cot, and then recover, a wooden reel attached to a string. As he expels the object the child utters the sound 'ooh!' He retrieves the reel with the sound 'da'. Freud and the child's mother both understand the child's vocalizations as renderings of the German words *fort* and *da* – 'gone' and 'there'. Freud interprets the child's 'game' as its rehearsal of the painful experience of its mother's absences, a game in which the child gains mastery in symbolic representation over what it cannot control in reality.[35] Jenni is in full control of her presence and absence in her room. Her mastery of her own

coming and going in effect puts her in the maternal position in relation to the individuals who log onto her website. I have already noted that the JenniCam opens a window in the computer screen that remains open whatever other activity the computer is engaged in. I suppose that many of these are work activities. Even at this moment windows onto Jenni's room may be opening through countless spread sheets and company reports, unfinished novels and academic papers. Abandoned in the workplace, these lonely adult children watch through their windows for Jenni to come home from work.

Those familiar with Baroque music may know Henry Purcell's setting of a reflection on solitude by the seventeenth-century poet Katherine Philips. The poem begins 'O solitude, my sweetest choice', and ends with the affirmation: 'Oh how I solitude adore!'[36] Any verbal address implies an addressee. The solitude one *speaks* is already compromised. In the last word of the penultimate line of Philips's poem there appears an unidentified 'thee'. Philips is able to find solitude her 'sweetest choice' because she is alone *in the presence of someone*. Some modern recordings of the song identify the addressee by adding 'O Lord!' to the original text. This agrees with the conventional piety of the period in which the poem was written. But from a psychoanalytic point of view the indeterminate form of the original is the more eloquent. From this point of view the 'thee' is not the father in heaven with whom one hopes to be united, but the mother on earth from whom one has had to separate. The small child separating from its mother's body clings to some thing, often a battered toy. The child may hold conversations with the toy. The scenario is familiar enough. The toy here serves the child both as transitional object and imaginary companion.[37] Jennifer Ringley's QuickCam might seem an unlikely confidant. With its circular lens set in a white sphere it resembles an eyeball.[38] Some might see it as an evil eye. But it could equally be assimilated to all those cheerfully friendly clocks, coffee pots and other domestic utensils that happily romp through children's books and animated cartoons. There is certainly no indication that Jennifer Ringley saw her QuickCam as anything more sinister than a cutely

bald version of her curled-up hedgehog Spree. In the newspaper interview she says: 'I'm inhabiting a virtual reality in which the camera feels like a little buddy.'[39] Jenni's apparent assumption that the gaze is fundamentally benign cannot be based on the evidence of history, or the testimony of the contemporary news media, or her own experience. Her optimism can only be a consequence of early maternal attention that, in Winnicott's somewhat truistic formula, is 'good enough'. But the basic benevolence Ringley assumes must surround her, that which is the precondition of the 'contentment' that Katherine Philips finds in solitude, cannot be guaranteed. In the year before she died, Melanie Klein wrote a paper 'On the Sense of Loneliness'. Klein says she is not referring to 'the objective situation of being deprived of external companionship'. She is rather speaking of 'the inner sense of loneliness – the sense of being alone regardless of external circumstances, of feeling lonely even among friends or receiving love.'[40] Klein locates the origin of this, for her, ineradicable sense of loneliness in nostalgia for the plenitude of the earliest union with the mother. A time before differentiation in which the infant's desires were understood by the mother without their requiring to be alienated in language. Philips enjoys the delights of solitude in places 'remote from tumult and from noise'. The French may rebuke a noisily exhibitionistic child with the words 'Arrête ton cinéma!' If Jenni's exhibitionism is a form of cinema, albeit a strange cinema of 'truth one frame per one-hundred-and-eighty seconds', it is a silent cinema. The commentaries she provides on her Webpage, and the commentaries of those like myself who write about her, provide some intertitles. But these verbalizations are after the fact. Jenni's originary form of address was, and remains, essentially mute.

James Baldwin tells us: 'To ensure privacy, Giovanni had obscured the window panes with a heavy, white cleaning polish.'[41] Anyone who has closed their curtains at night might feel they perfectly understand Giovanni's behaviour. But as James Baldwin leads us to know his fictional character better he reveals that Giovanni is not motivated by either simple propriety or corporeal modesty. His apparently 'normal'

desire for privacy is driven by pathological guilt. The gaze Giovanni seeks to escape is a very particular one: a judgemental gaze. Baldwin, like Freud, reminds us that it is not by looking that we may learn what people are doing when they look, or when they shield themselves from the gaze of others, or – like Jennifer Ringley – when they expose themselves to the other's gaze. It was obvious to the journalist who interviewed Ringley that she was an exhibitionist. He concedes, however, that she might have remained only a 'latent exhibitionist' if it had not been for the Internet. We are used to hearing dramatic claims about the effects of newly emerging technologies. My own claim here is a comparatively modest one, something of an anti-climax: new technologies confront image theorists with questions that may be most productive when they are least questions of technology. In the mid-1970s Laura Mulvey's essay 'Visual Pleasure and Narrative Cinema' inaugurated much debate about voyeurism. In retrospect it now seems surprising to me that little attention was paid to the complementary question of exhibitionism. I owe my surprise to the JenniCam.

4 The Remembered Film

The first sequence:

A static view across a corner of a park. In the foreground a mound
of freshly excavated earth alongside a path. In the background some
high-rise buildings. In long shot a woman enters frame right. The
camera dollies alongside as she walks along the path, then stops and
pans to follow her as she turns to walk uphill and out of frame. Cut to
a high point of view, looking downhill. In very long shot, diminutive
in the cityscape, the woman climbs a path towards the camera. She
arrives at an area set out with rows of benches. In the foreground a
man sits reading a newspaper. The woman sits some rows behind
him. Her head is framed in close-up against the sky. The wind tugs
at her hair. She begins to cry. She cries as if the same undisclosed
impulse that led her to walk now leads her to cry, as if her weeping
continued her walking.

The second sequence:

A static view across a valley of fields and woods. In long shot a woman
enters frame right, walking briskly and glancing back across the vale.
The camera pans and tilts left to follow her as she crosses the frame.
She turns to look uphill in the direction she is walking. Dissolve to a
high point of view, looking downhill. In very long shot, diminutive in
the landscape, the woman walks along a path towards the camera.
Dissolve to a medium shot as she advances through a stand of trees.
Clearing the grove she confronts a distant view of a cathedral seen
above tree tops. Her head is framed in close-up against the sky. The

wind tugs at her hair. She seems to hear music and voices in the wind. The sounds end abruptly on a cut to a very long shot of the woman alone and small in the landscape.

The first sequence, of about twelve minutes' duration, is in colour and is from Tsai Ming-Liang's film *Vive l'amour*.[1] The second sequence, of about five minutes' duration, is in black and white and is from Michael Powell's and Emeric Pressburger's film *A Canterbury Tale*. Fifty years separate the two films: the first is from 1994, the second from 1944. Some 15,000 miles separate their settings: Taipei, on the island of Taiwan, and the Downs, near Canterbury in the south of England. Nevertheless, the two scenes have become inseparably associated in my memory. Both show a woman walking, but although I can recall other such scenes none of them clings together so insistently as do these two. If I replay them I can see relations of antithesis between them: town and country, old world and new, East and West. I can also see figures of antithesis within them: the urban park in Tsai Ming-Liang's film is a scene of devastation, a wasteland pitted with flooded craters and littered with uprooted stakes, spattered at the edges by red spots of flowers in tubs, suggesting the carnage of warfare in a place of peaceful recreation; the verdant idyll in Powell's and Pressburger's film is studiously oblivious to the World War raging beyond its tranquil frame. Such observations after the fact might explain my tendency to think of the two sequences together, but I feel there must be more than merely formal grounds for my association of the two. I know the stories told in the two films, I know what I am supposed to feel, and what judgements I might make, but the peculiarity of my relation to the sequences has nothing to do with the stories in which they were originally embedded. The narratives have dropped away, like those rockets that disintegrate in the atmosphere once they have placed their small payloads in orbit. Detached from their original settings each scene is now the satellite of the other. Each echoes the other, increasingly merges with the other, and I experience a kind of fascinated incomprehension before the hybrid object they have become.

In his book *Camera lucida* Roland Barthes speaks of being emotionally touched by a detail in a photograph. The image is a family portrait made in Harlem in 1926 by James van der Zee. The people in the photograph, two women and a man, are unknown to Barthes. He nevertheless feels 'a kind of tenderness' aroused by the ankle-strap on the shoes worn by one of the women. At first he cannot account for the feeling, but later, remembering the picture, he realizes that the emotion he felt was prompted not by the ankle-strap but by the woman's necklace. He now recalls a similar necklace once worn by an aunt who had passed all her life by her mother's side in a dull provincial town. Barthes writes: 'I had always been saddened whenever I thought of her dreary life.'[2] No road of reason leads from the smart strapped shoe in Harlem to the sad life in a French town. The connection could not have been anticipated, and although it was involuntary it was not immediate. Barthes says that the photograph 'worked within' him before he knew where the feeling came from. One of Freud's patients told him that she had once suddenly found herself in tears while walking in the street.[3] When she asked herself what she might be crying about she came up with a fantasy. She imagined she had had an affair with a well-known pianist, and had had a child by him; she imagined that her lover had then deserted her and the child, leaving them in poverty. This fantasy, she believed, was the cause of

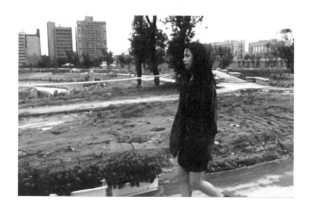

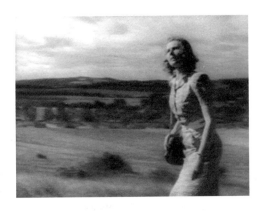

her tears. Freud found that emotions, 'affects', may become dissociated from the 'representations', such as memory-traces or fantasy images, to which they were first attached.[4] The anecdote told by Freud's patient illustrates how an affect may be experienced in isolation from the representation with which it was originally associated. The account that Barthes gives of his response to the family photograph shows how the affect may not only be detached from the original representation but displaced onto other representations. It illustrates how in the course of everyday life a chance encounter with an image may give rise to an inexplicable feeling, and how, by retracing the path taken by the affect, we may be led back to its origin in a suppressed or repressed idea.[5] Freud's patient identifies no equivalent of the image of the necklace to trigger the emotion she felt. But there must have been some precipitating cause, otherwise why did she burst into tears at that moment and not at some other?

We have probably all had the experience of finding that our mood has taken a turn for better or worse without our knowing why. It may take the prompting of someone close to us to lead us to uncover the cause in a memory or fantasy, perhaps provoked by a real or remembered image. Or we may find the cause without external help, by groping around in the dark. Before Barthes attributes his feeling of tenderness to the sight of the ankle-strap, he first mentions the belt on

the woman's dress. Later, he reassigns the provoking cause of the emotion to the woman's necklace. On the trail of the enigmatic feeling he passes from a scene (the family group) to an object within the scene (the ankle-strap) to a gesture (the circling of a body part) that is first displaced throughout the scene (belt, shoe, necklace), and then beyond this scene to another scene (the life of the aunt). Barthes says that the photograph 'worked within' him, as a silent and unselfconscious process. After Freud we may identify this process as that of the 'dream-work', the workings of the unconscious that are not confined to the dream but pervade our waking life. Barthes traces his feeling of tenderness to a memory. Freud's patient traces her tears to a fantasy. But it is unlikely that either of them had arrived at the end of the trail. For example, we may wonder why, in composing her fantasy of an ideal love affair, Freud's patient should invent such an unhappy ending. Who did the figure of the pianist represent that she should be so painfully punished for her relationship with him? As Freud provides no further details of this analysis we can only speculate.[6]

A model illustration of the mechanisms of associative chains is provided in an account of a case history given by the French psychoanalyst Serge Leclaire. Philippe, 30 years old, is in analysis with Leclaire. One day he goes for a walk in the forest with his niece, Anne. That night he dreams:

> The deserted square of a small town, it is not quite right. I am looking for something. There appears, barefoot, Liliane, who I do not know, who says to me: 'It has been a long time since I have seen such fine sand.' We are in a forest and the trees appear curiously coloured, in bright and simple hues. I think that there are many animals in this forest, and, when I'm about to say this, a unicorn crosses our path. We walk, all three of us, towards a clearing we can see below.[7]

Philippe's associations to the dream lead to three memories from childhood. He recalls a square at the centre of a small provincial town

in France. In the square is a drinking fountain topped by a carving of a unicorn. This is the fountain that he felt was missing from the square in his dream. He remembers drinking at the fountain when he was three years old, cupping his hands to receive the water. During his walk with Anne the previous day Philippe had remarked on their surroundings. He said he had not seen such brightly coloured heather since a holiday in Switzerland when he was five years old. It had been on this holiday that he had learnt from an older boy how to make the sound of a siren by cupping his palms and blowing between them. Philippe now remembers a holiday at the beach when he was about the same age. He was left in the care of his mother's cousin, Lili. He was always thirsty that summer and Lili affectionately mocked his repeated solicitations. The small Philippe would complain: 'I'm thirsty' (*J'ai soif*); 'Me-I, I'm thirsty' (*Moi-je, j'ai soif*). Lili names him after one such formulation, hailing him with the words: 'Philippe-I'm-thirsty' (*Philippe-j'ai-soif*). This expression becomes the secret sign of their complicity. Philippe can now identify the 'unknown' woman in the dream, disengaging his childhood guardian 'Lili' and his companion of the day 'Anne' from the name 'Liliane' where they were entangled. Philippe's further associations eventually lead into normally inaccessible reaches of unconscious formations, into what Freud called the 'umbilical' of the dream. Leclaire's account of the dream of the unicorn, and a related dream, extends across several essays and a book. The analysis allows Leclaire to believe he has reached: '. . . an endpoint beyond which we cannot go: . . . one of those knots that constitute the unconscious in its singularity.'[8] This singularity, according to Leclaire, is composed of the elements he calls 'letters'.

The 'letter' is the imaginary representation of a corporeal site, the psychical representative of either an erotogenic zone or some other inscription on the body. In the case of Philippe such 'letters' include a scar (the place where a gaping of the corporeal envelope has been filled), the gesture of cupped hands, and the syllable 'zhe' (*je*). In the vicissitudes of a personal history such cuts, hollows and vibrations may become no less components of the corporeal imaginary than are

the oral and anal apertures specified in 'classical' accounts of the component drives.[9] The 'letter' belongs to that class of 'objects without otherness' of which Lacan says: 'They are the lining, the stuff or the imaginary thickness of the subject himself who identifies with them'.[10] After following the twists and turns of Philippe's associations – like so many converging, diverging and intersecting paths in a forest – what most interests Leclaire is the way in which all such imaginary derivatives of Philippe's primitive relation to the body, from which the maternal body has not yet been dissociated, have become condensed in the sounds of a secret name that the child gave to himself, 'Poordjeli'. Leclaire writes from within Lacan's circle and it is unsurprising that the 'letter' he emphasizes is one that may take a phonemic form. Nothing in Leclaire's account, however, commits us to such exclusivity. It is clear, for example, that the epidermal sensation of contact with a grain of sand is amongst the primitive 'letters' tallied in Philippe's analysis. Nevertheless, the secret name illustrates most clearly the mechanisms of the unconscious processes at issue here. The 'por' of 'Por-Je-Li' is formed from broken-off syllables of the subject's first and middle names, Phili-pp-e and Ge-or-ges, and is also contained within other key words in the anecdotal material, such as *peau* (skin) and *corps* (body). 'Je' also part of *Georges*, it is the *je* of *Moi-je*, of *j'ai soif*, and a part of *plage*. It is the *je* of his engulfing mother's *je t'ai!* (I've got you!), and also part of *rage* (rage) and *sage* (used of a child who is well behaved). It is the monumental inscription of the monogram 'J. E.' on his grandfather's suitcase, which he later learns to decipher. 'Li' is of course contained within both 'Philippe' and 'Lili'. It is the erotic crossroads where they are amorously joined. It is also part of *licorne*, the image in which Lili and the phallus are fabulously combined. (Philippe has a scar in the middle of his forehead.) As Serge Leclaire and his collaborator Jean Laplanche elaborate, in a co-authored essay, on the case history of *Philippe-j'ai-soif*,[11] they return to that semantically dense phonic image – zhe. The sound is used in common by everyone who speaks French. At the same time it plays a part in the irreducibly private staging of Philippe's desire. Laplanche

finds an analogy in 'those puzzle drawings in which a certain percept-ual attitude suddenly makes Napoleon's hat appear in the branches of the tree that shades a family picnic.'[12] In a scene equally available to us all, that means the same to us all, there is an opening onto a destina-tion towards which only one of us will be drawn.

Outside a clinical setting, the anecdotal details of Philippe's personal life are of little interest to others. But the mechanisms by which his life returns to him in an image flux may help us to under-stand the modes of our reception of the everyday environment of images. I use the expression 'everyday environment of images'. For the sake of brevity I might refer to this environment simply as the 'envelope'. Inhabitants of wealthy nations are enveloped by images. Suppose I get up one morning with a day of leisure before me. Over breakfast I read a newspaper, looking at the photographs printed on its pages and forming mental images of events described in its columns. Later, in the street, I am seduced or assailed by advertising images of all kinds, from posters in bus shelters to images that cover the sides of high-rise buildings. I may be on my way to an art museum to spend time with a certain painting. Or I might have chosen to search for a recording of some music, flipping through images on the covers of compact discs. Later, I spend time browsing the shelves in a bookstore. Back at home I watch the evening news before going out to see a film. After dinner I search the Internet for hotels for a trip I am planning, scrutinizing pictures of façades and rooms. Then I desultorily zap my way through disparate television channels before giving up in favour of bed and the novel I came across while book-shopping. I fall asleep with the landscape of the novel before my mind's eye. Freud spoke of the 'day's residues'[13] that contribute to the formation of dreams. But before sleep, at any time of day, I may find myself caught in an inchoate waking dream in which recollections of recent encounters with images combine with memories and fantasies. The place of such constructs is, in Donald Winnicott's words, 'in the area between external or shared reality and the true dream'.[14] For Winnicott, this is quite simply the *location of cultural experience*.[15]

Today, what we share in common in cultural experience is increasingly derived from the image envelope. In the most usual sense an 'envelope' is that which contains and conceals a letter. Our daily individual experiences of the image envelope may secrete derivatives of 'letters' in the psychoanalytic sense that Serge Leclaire has given to the term. In bringing insights from psychoanalysis to our understanding of our relation to the image envelope, the question of what is private and what is public must be held in suspense. The question cannot be decided in advance of the analysis, but only retrospectively, at its conclusion.

The example that Roland Barthes gives of his experience of looking at and remembering the van der Zee photograph is one of several examples collected in his book *Camera lucida*. Such details as the necklace in this photograph, which move him in a way that is strictly incommunicable, he calls the punctum. Of course the punctum is not the only occasion for an emotionally invested experience of a photograph. Barthes acknowledges that there are photographs that many people in common will find moving, and for reasons that may easily be explained. Here, says Barthes, the emotion derives from 'an average effect, almost from a certain training'. He calls this common ground of meaning the studium. Barthes had made a closely similar distinction in an earlier essay, where he distinguished between the 'obvious' and 'obtuse' meanings of some film stills.[16] We may bring much the same distinction to other images from the everyday environment. I switch on the television. Two men are in a tense exchange in a bar in the tropics. One has announced to the other his intention of marrying. The other disapproves. He thinks the woman is no good. The marrying man, whom I recognize as Jack Lemmon, asks his friend, whom I recognize as Robert Mitchum, to make one more trip to sea with him. Then they will sell their boat and split the proceeds. 'Keep the money', growls Mitchum, 'for a wedding present'. Cut to the boat dock at night. Lemmon is in a tense exchange with another man. Behind them is a painted backdrop of palms. A woman arrives to wave from the dock as the boat departs. The palms behind her are

real. I recognize the woman as Rita Hayworth. I feel slightly tense, a little anxious for Jack Lemmon. Also a little bored. Apart from the boredom I am obviously feeling what I am supposed to feel. I turn off the television. I open the current issue of *The Cableguide*[17] and identify the title of the film as *Fire Down Below*.[18] I read:

> *Fire Down Below* (1957). A shady woman (Rita Hayworth) comes between fishing-boat partners (Robert Mitchum, Jack Lemmon).

This brief synopsis of the narrative tells me nothing I did not already know. Within minutes of switching on the television it was clear that a woman had come between these men. It was clear that Robert Mitchum loved Rita Hayworth but could not accept her because of her morally compromised past. It was clear that Rita Hayworth was a good woman fallen on hard times who was marrying Jack Lemmon because he was a nice man. It was clear that she really loved Robert Mitchum. It was clear that Jack Lemmon would get hurt. It was clear that things would turn out disastrously for all concerned. The fragment I saw was all that was required to retrieve this narrative from the archive of the 'already seen'.[19] But already, in memory, the obvious meaning of the film is giving way to obtuse meanings. The 'already seen' of the story hovers like an aura around the sequence of the farewell at the jetty, but already the narrative is fading. The jetty scene is itself decomposing into its component images: Jack Lemmon against a nocturnal painted backdrop, Rita Hayworth on a jetty in a *nuit américaine* of blue-filtered daylight. What was once a film in a movie theatre, then a fragment of broadcast television, is now a kernel of psychical representations, a fleeting association of discrete elements: a voice full of urgency; the passive indifference of painted-palms; a woman waving across the unbridgeable gap that separates the real jetty where she stands from the studio set where a man pretends to leave. The more the film is distanced in memory, the more the binding effect of the narrative is loosened. The sequence breaks

apart. The fragments go adrift and enter into new combinations, more or less transitory, in the eddies of memory: memories of other films, and memories of real events.

In 1977 sociologists at the University of Provence began a ten-year oral history research project in which they conducted more than 400 recorded interviews with residents of the Marseille/Aix-en-Provence area. They asked each interviewee to describe her or his personal memories of the years 1930 to 1945. They found an almost universal tendency for personal history to be mixed with recollections of scenes from films and other media productions. 'I saw at the cinema' would become simply 'I saw'.[20] For example, a woman speaks of her experiences as a child amongst refugees making the hazardous journey from the north of France down to Marseille. She recalls the several occasions when the column of refugees in which she was travelling was strafed by German aircraft. In recounting these memories she invokes a scene from René Clément's film of 1952, *Jeux interdits*, in which a small girl in a column of refugees survives an air attack in which her parents are killed. The woman's speech, however, shifts between the first and the third person in such a way that it is unclear whether she is speaking of herself or of the character in the film. The interviewer learns that the woman had in reality been separated from her parents on the occasion of such an attack and had been reunited with them only after many anxious days without news. As the interviewer comments, 'It is reasonable to think that the death of the parents in the film figured the possible death of her real mother . . . '.[21] From the confusion of subject positions in the woman's speech we might suppose that the scene in the film in which the parents of the young heroine are killed, when they place their bodies between her and the German guns, has come to serve as a screen memory covering her repressed fantasy of the death of her own parents. A 'screen memory' is one that comes to mind in the place of, and in order to conceal, an associated but repressed memory.[22] Freud remarks that screen memories are marked by a vivid quality that distinguishes them from other recollections. It seems that the woman's memory of the film has similarly

become fixed on this one brilliant scene of the attack from the air, as if it were the only scene from the film she remembered.

For me, it is as if the two scenes with which I began are the only scenes I have remembered from those two films. I know there are others, but it is as if they lack illumination. As I revisit them again in memory I find myself recalling the house in which I spent most of my early life. The house is on the side of a hill. When my mother went out shopping, or to visit relatives, or for whatever other reason, she would descend this hill. Before I was old enough to be left alone I would descend with her, and climb the hill afterwards. So much walking, so much climbing, clearly invested with great purpose by my mother, but so often incomprehensible to me. The house was in a fringe of houses bordering the tangle of streets and factories that filled the valley below. Beyond this fringe the paved streets gave way to dirt paths through ruined allotment gardens. The broadest path first ran alongside an industrial spoil heap. Then further paths turned off to lead higher, to the few remaining fields of a failing family farm, a part of the rural past stranded on these slopes as industrialization engulfed the valley. Beyond the farm the slopes inclined even more steeply and the trails struggled to a barren summit, where the wind tugged at the hair. As I try to bring my attention back to the fragments of film, I find another scene from childhood joining them. I now confront a mutating 'scene' in every sense that the dictionary allows this word: a view or prospect seen by a viewer; the place where an action or event occurs; the setting of a play, film, novel or other narrative; a sub-division of an act in a dramatic presentation, in which the setting is fixed and the time continuous; a shot or series of shots in a film consti-tuting a unit of continuous related action; the scenery and properties for a dramatic presentation; a theatre stage; a real or fictitious episode, especially when described; and a public display of passion or temper.[23] The memory that has joined the previous fragments is this:

> The living room of a modest house. A small boy, perhaps four years old, is in the company of two women: his mother and

her sister-in-law. They are standing together in front of a fire-place, above which is a mirror. The boy's aunt is trying on a blouse. The boy watches the women as they appraise the garment reflected in the mirror. The aunt removes the blouse, revealing a white bra. Trying on a word only recently acquired, the boy asks: 'Are those your tits?' The calm shatters. His aunt, pulling on her blouse, smiles but seems disconcerted. His mother is angry and makes reproaches he does not fully understand.

Could this be the originating occasion of my 'fascinated incomprehension' before the memory of the two film sequences, the matrix for my puzzling over what is the same and what is different between them? When I began writing this paper I had misgivings about making public my chance associations to two short sequences of remembered films. When the type of theoretical work on photography and film in which I have been involved emerged in the 1970s it was concerned with explaining the ways in which films and photographs contribute to the formation, perpetuation and dissemination of dominant systems of commonly held beliefs and values. It was emphatically not concerned with whatever irreducibly subjective meanings an image might have for this or that individual. It seems I need not have worried. What I find at the end of my 'autobiographical' trail, which I supposed might concern no one but myself, is the *mise-en-scène* of a riddle we all must answer at one time or another, in one way or another, and to which we must perhaps find new answers each day of our lives: the enigma of sexual difference. It is perhaps disappointing that the path I have followed should have led only to such a banal fact as that of the difference between the sexes. Narcissism prefers we arrive at more important or wonderful destinations. But nothing is more important to the identity of the emerging subject than this; the baffling fact of sexual difference presents the child with an object of wonder. Certainly, the echoes of the questions that sexual difference occasions, and of the 'answers' that lead only to more

questions, may be discerned throughout the popular productions of the media, and those less popular productions we call 'art'.

The third sequence:

A static view down a wooded slope towards a large country house. Dissolve to a long shot of a woman looking across a wooded park. Cut to a close-up of a ripe fruit hanging from a branch. Dissolve to a solid red frame as a woman's voice speaks some sentences in German. Cut to a medium shot of a woman looking from a window towards a path winding up a meadow between trees. Cut to a long shot of the woman on the path looking back towards the house. Cut to a low point of view as the woman climbs the hill, nearing a stand of trees at the summit. Cut to the woman seen from behind as she looks over meadow and trees to the house below and the horizon beyond.

This third sequence is of about three minutes' duration and comes from my own video projection work *Lichtung*. The work was shot in the Ettersberg forest, near Weimar, and was first shown in 1999. The

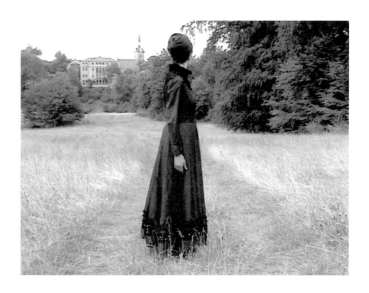

correspondences between this sequence and others I have discussed here may be apparent, but they did not occur to me until I had completed the penultimate draft of this paper. The connections illustrate the observation with which I shall conclude. Chains of associations may lead as far into individual history as those traced by Leclaire in his analysis of Philippe. More usually they lead no further than Barthes travelled in his account of the van der Zee photograph, or than I was able to go in my memory of childhood.[24] But associations lead not only to roots in personal history. In selectively incorporating fragments from the image environment they also branch out to weave private and public into a unitary network of meanings. In the end, the question 'What is the origin of this psychical object?' is of less importance in life and theory than the question 'What use am I able to make of the object?'[25] Our forgotten answers to distant questions may reverberate down history to shatter remembered films. But what concerns us most is what we make from the fragments.

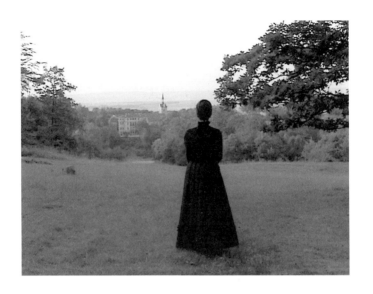

5 Mies in Maurelia

for Nuria and Noemi

In Maurelia, the traveller is invited to visit the city and, at the same time, to examine some old postcards that show it as it used to be: the same identical square with a hen in the place of the bus station, a bandstand in the place of the overpass, two young ladies with white parasols in the place of the munitions factory. If the traveller does not wish to disappoint the inhabitants, he must praise the postcard city and prefer it to the present one, though he must be careful to contain his regret at the changes within definite limits: admitting that the magnificence and prosperity of the metropolis Maurelia, when compared to the old, provincial Maurelia, cannot compensate for a certain lost grace, which, however, can be appreciated only now in the old postcards, whereas before, when that provincial Maurelia was before one's eyes, one saw absolutely nothing graceful and would see it even less today, if Maurelia had remained unchanged; and in any case the metropolis has the added attraction that, through what it has become, one can look back with nostalgia at what it was.

Beware of saying to them that sometimes different cities follow one another on the same site and under the same name, born and dying without knowing one another, without communication among themselves. At times even the names of the inhabitants remain the same, and their voices' accent, and also the features of the faces; but the gods who live beneath the names and above places have gone off without a word and

outsiders have settled in their place. It is pointless to ask whether the new ones are better or worse than the old, since there is no connection between them, just as the old postcards do not depict Maurelia as it was, but a different city which, by chance, was called Maurelia, like this one.

Italo Calvino, *Invisible Cities*[1]

I am in Barcelona. I find the genius of the place, which for me is where my inner world and the reality of the city intersect, in Mies van der Rohe's German Pavilion for the 1929 International Exhibition. Embarrassing, as if I had gone to Paris and discovered the Eiffel Tower. I must nevertheless accept the fact that the pavilion haunts me. Before visiting Barcelona I had known the building only from old photographs, as one lost monument to modernism amongst others.[2] If the 1986 reconstruction of the pavilion haunts me now it is because Barcelona haunts the pavilion. I climb from the Plaça d'Espanya to the site of the 1929 building and its 1986 reincarnation. I enter the pavilion only to find myself leaving. The space behaves like the moebius strip dear to science-fiction writers. In one such story, a roller coaster is unwittingly constructed with such geometry that those who take the ride emerge decades from the point at which they began. I feel I might emerge from the reconstructed pavilion into the Barcelona of 1929, with history poised motionless before it plummets towards the fascist occupation of the city a decade later. I take another turn through the building. No point of rest amongst its mirrored planes, but one constant point of reference: Georg Kolbe's statue of a standing figure. The bronze, titled *Sunrise*,[3] shows a woman with arms raised to shade her face from the light. The title disavows the violence in this image of a woman cornered: her face averted as if from an undisclosed horror. On the slopes of Montjuic, I find myself thinking of the summer house on the hill in Goethe's short novel *Elective Affinities*. The book's four main characters embark on a scheme of improvements to a country estate that includes the construction of a pavilion. Things turn out badly. Goethe's novella suggests natural

relations between rationalism and disaster, geometry and disillusion. No pavilion was built in Goethe's time on the estate near Weimar which must have served as model for the topography in his story.[4] The real hill remained undisturbed until 1937, when the Buchenwald concentration camp was built there. Guernica was bombed in the same year.[5]

The German Pavilion conceals as much as it reveals. Eight slender cruciform columns support the roof, chromed to render them all but invisible. But the roof also receives support from heavier structures hidden behind stone cladding, and the podium base slab is supported by traditional Catalan brick vaults. There is more here than meets the eye. Beatriz Colomina urges us to 'realize that "what counts" in Mies's buildings is not how they are really built, but what they "look like." What counts, then, is their image, their photographic image.'[6] Why do I think of police photography? Reading about the meticulous assembling of information through which the pavilion was reconstructed I was reminded of detective work, as if I am now visiting the scene of a crime. I read that the most immediate prototype of the German Pavilion was the 'Crystal Hall' that Mies van der Rohe designed in collaboration with Lilly Reich for the 1927 Werkbund exhibition in Stuttgart. The Crystal Hall was built as an installation for the section of the exhibition devoted to 'Glass'. The screens that articulate its space are composed of different types of this material, with differing degrees of transparency and reflection. The visitor is presented with much the same 'mirror maze' play of ambiguously real and virtual spaces that confronts the visitor to the German Pavilion. As in the later structure, the Crystal Hall contains a single sculpture of a female nude. Photographs of the Werkbund installation, albeit of poor quality, nevertheless suggest that the sculpture is the work of Wilhelm Lehmbruck. This may lend plausibility to the prevailing account of how Kolbe's statue came to Barcelona:

> Mies was very anxious to borrow a Lehmbruck figure for this spot; and when this proved to be impossible to arrange, he

grabbed a taxi on one of his last days in Berlin before leaving for Barcelona, drove out to Kolbe's studio, and borrowed the best substitute he could find.[7]

Certainly it may be assumed that works by Lehmbruck would have been more difficult to obtain in 1928 than those of Kolbe. Although Lehmbruck was born four years after Kolbe, he died in 1919 – whereas Kolbe was still vigorously producing at the time when, according to the story, Mies hailed the cab. Whether or not the taxi ride ever took place it takes us down the wrong road. It would be a mistake to scour Lehmbruck's *oeuvre* for significant insights into the Miesian imaginary. It is not the intrinsic quality of the statue that is significant so much as the relation of the figure to the space. In the Crystal Hall, the visitor is separated from the sculpted female figure by a barrier of glass. In the German Pavilion, the visitor is separated from the figure by a barrier of water. I think of Mies van der Rohe's solitary female client in the isolated glass enclosure of the 1946 Farnsworth House. Not touching – like the walls themselves, which perpetually reach towards the closure of contact with another plane, another surface, another skin, but fail to close the gap.

Mies van der Rohe spoke of 'the necessity of incorporating works of sculpture . . . into the interior setting from the outset. In the great

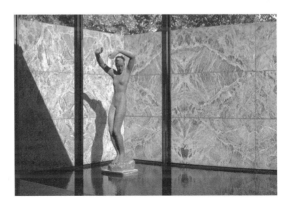

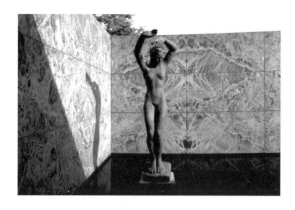

epochs of cultural history this was done by architects as a matter of course.'⁸ Josep Quetglas has compared the Barcelona pavilion to the Doric temple; not the one we see today, 'the columns which travelling architects always inevitably sketch and photograph',⁹ but the temple that the Greeks saw. This, Quetglas reminds us, was the house of God, which 'differed from other houses only in that it did not admit visitors'. The screen of columns and the raised platform formed a double barrier between the worshippers and the space from which they were excluded: the inner sanctum (the cella, or naos) which contained the shrine or statue of the divinity. The frozen gesture of Kolbe's statue suggests those of bodies disinterred from the ancient ashes of Pompeii. The mid-eighteenth-century excavations of Pompeii and Herculaneum prompted both the neo-Classical revival and a renewed fascination for the ruin. There are distant echoes of both in the German Pavilion. If the German Pavilion is a temple then it is the ruin of a temple. The walls of the naos remain standing. I can enter its space and I can look upon the statue, but I cannot shake either the feeling of exclusion or the sense of violation. In the eighteenth century what today we call neo-Classicism was the other face of Romanticism. In the ideal landscape garden it was a short step from the reconstructed Doric temple to, in the words of Shaftesbury, 'the rude rocks, the mossy caverns, the irregular unwrought grottos and broken falls of waters, with all the horrid graces of the wilderness itself.'¹⁰

Harmony gives way to entropy. The present tense of building houses a future anterior: 'in time, this will have become a ruin'.

The precise profile and dimensions of the cruciform columns of the German Pavilion were determined only when a rusting stump of pillar was unearthed during the excavation of the site of the 1929 building. The lower basement level of the Barcelona City History Museum opens onto the subterranean ruins of a first-century Roman city: vestiges of buildings, streets, stumps of columns and skeletal walls. A walkway is suspended just above the excavation floor. Its almost invisibly light construction gives a sense of floating to the sunken *flâneur* who drifts among the stones like a ghost from the future: a living body amongst deceased buildings, a haunting in negative. Rising from the dead city one may go to see displays on the upper levels of the museum. During the summer of my own first visit a temporary exhibition was devoted to the Barcelona of 1939, the year the city fell to the Nationalist forces. Among the photographs and eye-witness reports on display I read of a group of university students who had been arrested by the police for possessing anti-fascist leaflets. The students were taken to jail, where they were tortured. The only woman with them died under torture. Some 600, 000 Spanish people were killed in the three years of Civil War that ended with the fall of Barcelona and Madrid in 1939.[11] The story of the death of that one young woman remained in my mind as I left the museum and entered the Barcelona of today: the darling of international property developers, famously reconstructed for the Olympic Games of 1992 and now preparing for the 'Forum of Cultures' in 2004 – on which pretext, that summer of 1999, bulldozers were ripping their way through the 'Barrio Chino'. In the cacophony of this destruction, that one death persistently returned to mind, and remained there as I walked around the German Pavilion. The story refused to be integrated into the semantic fabric of the contemporary city, and perhaps as a consequence the pavilion itself refused to be incorporated into this new Barcelona. Images from the period between the fall of the German Pavilion in 1930 and its resurrection in 1986 are not

repressed, but they do not fit into the present picture; they are scattered like superfluous jigsaw pieces around a triumphantly completed puzzle.

The German Pavilion was built to stage a gesture – that of the Spanish king, Alfonso XIII, who formally inaugurated Germany's participation in the World Fair of 1929 by signing his name in a ceremonial book: the 'Golden Book'. On my third turn through the pavilion I divide the space into three primary zones: small pool area, large pool area and the intervening site of the diplomatic ceremony for which the pavilion was designed. Each zone offers its own point-of-view of Kolbe's statue: in close, medium and long shot. I am here to make a video,[12] and I centre a panorama on each of the three points. Later, in assembling the video, I divide each panorama into three, weaving together the different points of view. In *The Odyssey*, Homer tells the story of Penelope. Her husband, Odysseus, left for the war many years ago. There has since been no news of him, and most now suppose him dead. Various suitors press Penelope to remarry. She says she will choose between them when she has finished weaving a shroud for her stepfather. She weaves all day, but at night she unpicks her work. The next day she begins again. Jean Laplanche invokes the Homeric tale as an allegory of the work of psychoanalytic interpretation, which he characterizes as 'the splitting up of signifying sequences, be they present or past', in order that the analysand may effect 'a new synthesis or translation, one that is less partial, less repressive, less symptomatic'.[13] In the usual telling, Penelope is the avatar of the faithful wife, bound out of time to the siren call of memory. In Laplanche's exegesis, Penelope re-weaves the fabric of her life, unravelling the knots of her past with Odysseus to design a future without him – but without breaking the threads, without leaving her memories of Odysseus out of the picture.

The space allocated to the Golden Book is between two pools. In classical Greece, aspirants to the priesthood sought guidance from the Oracle in a rite of passage between two bodies of water. Before consulting the Oracle they first drank from the waters of Lethe. One of the

five rivers of the Underworld, Lethe has its source in the cave of Morpheus, the god of sleep and dreams; its waters bring forgetting to the dead, relieving them of the pain of their memories. What words and visions the Oracle might bring are to be imprinted on a *tabula rasa*: the way to revelation passes through amnesia. The ritual of consultation ends with the aspirant drinking from the waters of Mnemosyne, the goddess of memory. Mnemosyne restores the forgotten memories, but now transformed through oracular insight. In September 1926, Marie Bonaparte, descendant of Napoleon Bonaparte and wife of Prince George of Greece, entered analysis with Sigmund Freud. She was 44 years old. Since earliest childhood she had kept a meticulous journal of her everyday life. Between the ages of seven and ten she produced five notebooks of writings that were very different from the factual realism of the rest of her journals. Written mainly in English, in a scratchy cursive script that frequently breaks into visual images, the five books are filled with fantastic tales and ruminations. Having seen her infant cousin being breast-fed, she writes (in German):

> We are nine bad breasts. We are going to vomit. I am the ravisher of bad gold, and I always say, give me your gold. As I am beautiful, I do not like these women who have no breast. How beautiful I am. Essential proverb in life: A breast without a woman is better than a woman without a breast.[14]

Marie Bonaparte had kept all her writings from childhood and early adulthood, but she had put aside these five black notebooks, which she had entitled *Mes bètises*, and forgotten them until she came across them in her father's effects after his death. Those seeking guidance from the Oracle were warned not to drink too deeply of the waters of Lethe. When Marie Bonaparte first chanced upon her five notebooks she did not recognize them. She had no recollection of writing in them, and did not understand them. If she had not found her Mnemosyne in Freud she could not have re-woven their lines into her own history.

Told from the outside, without access to the *texture* of Marie Bonaparte's analysis, the tale of the notebooks might support the idea of memory as a kind of attic in which we rummage for long forgotten items. In this view forgetting is thought of as a form of passive neglect, and remembering as a form of active restoration. But forgetting is an endless *work* we must do if we are not to be overwhelmed by the constant accumulation of new impressions. Forgetting is not always the same kind of work, nor is it always easily distinguished from remembering. In an essay on Proust, Walter Benjamin asks:

> Is not the involuntary recollection, Proust's *mémoire involontaire*, much closer to forgetting than what is usually called memory? And is not this work of spontaneous recollection, in which remembrance is the woof and forgetting the warf, a counterpart to Penelope's work rather than its likeness? For here the day unravels what the night has woven. When we awake each morning, we hold in our hands . . . but a few fringes of the tapestry of lived life, as loomed for us by forgetting. However, with our purposeful activity and, even more, our purposive remembering each day unravels the web and the ornaments of forgetting.[15]

In Benjamin's description, involuntary recollection is as different from 'purposive remembering' as dreaming is different from waking thought. In placing involuntary memory on the side of the primary processes, and in emphasizing its kinship with forgetting, Benjamin places forgetting on the side of repression. Jean-Bertrand Pontalis has emphasized that repression does not act upon memories as such, but upon the mnemic traces that memories may secrete. A memory is something narrated; a mnemic trace is an element in the narrative that is nevertheless independent of it. Pontalis gives as examples of such traces the pattern on the wallpaper in one's childhood bedroom, the odour of the parents' bedroom, or a word caught in passing. Moreover, repression acts not so much upon the trace itself as upon

the *connections* between traces. It is in the course of a police investigation that individuals are enjoined to make a conscious effort to remember what they know about a past event. In a psychoanalysis the individual is asked merely to say whatever comes to mind. The course of an analysis depends less on the ability to remember than upon the ability to associate freely – which is to say, as Pontalis puts it, 'to dissociate existing, well established, liaisons in order to make others emerge, which are often dangerous liaisons'.[16] Marie Bonaparte could make no sense of the enigmatic inscriptions from her past until she had risked reconfiguring the pattern of her present that contained them.

The story I had read in the Barcelona City History Museum had left me under a cloud that accompanied me up to the time I visited the German Pavilion. On visiting Rome, Goethe saw in the profusion of marble statues a world of ghosts mingling with the living. Visitors to the German Pavilion mingle now in sunlight, now in shadow, now in reflection, now transmitted darkly through glass. At each turn Kolbe's statue slides to their side. Amongst the materials I had put aside in anticipation of my visit to Barcelona was a tape of a French television documentary about Catalonia and the Civil War. It mainly consisted of 'talking heads', with scraps of archival film footage scattered between. In one fleeting fragment a shyly smiling young woman, a rifle over her shoulder, raises her arm to shade her face from the sun. In my troubled frame of mind the gesture of Kolbe's statue appeared as that of a woman under attack, but it also prompted my recollection of the gesture of the smiling young woman in the documentary film. It was as if the statue faced, Janus-like, onto mutually contradictory meanings – as if I were telling myself, 'I know that the woman I read about in the History Museum was murdered in prison, but here she is alive and at liberty.'[17] It seems unlikely that my involuntary recollection of the film fragment was prompted by nothing more than a similarity between the gesture of Kolbe's statue and that of the woman in the documentary. In the bright streets of Barcelona I must have often enough seen arms raised to shield eyes from sunlight – whether

in reality or in advertising images. The association of the German Pavilion with the historical events of the 1930s must have played some part in triggering the association, but what of the building itself? In *Being and Nothingness* Jean-Paul Sartre describes going to a café to meet a friend. He arrives late and, looking around the café, sees that his friend is not there. Sartre asks himself what it means to say we can 'see' that someone is not there. He observes that his friend is absent not from any particular place in the establishment but from *all* of the café. As a consequence, the entirety of the café sinks into the position of 'ground' for the anticipated 'figure' of the absent friend. Sartre writes:

> The café remains ground . . . it slides in the background, it pursues its nihilation. But it only makes itself ground for a determinate figure, a figure it carries everywhere in front of it . . . and this figure, which slips constantly between my look and the solid and real objects of the café, is precisely a perpetual fading; it is Peter raising himself as nothingness against the ground of nihilation of the café. So that what is offered to the intuition is a fluttering of nothingness: the nothingness of the ground, the nihilation of which summons and demands the appearance of the figure, and that of the figure – nothingness which slides as a nothing on the surface of the ground.[18]

My encounter with the German Pavilion that summer was very different from that of Sartre entering his familiar Café Flore. Standing on Montjuic after years of knowing the site only from photographs, I might have thought, as did Freud on the Acropolis, 'So, all this really *does* exist.'[19] Nevertheless, I may describe my experience in the terms used by Sartre. I was aware of a persistent something that slipped constantly 'between my look and the solid and real objects' of the pavilion. For Sartre, this 'something' – a 'fluttering of nothingness' – was the absence of his friend. In my own case it was a cloud of affect nebulously conjuring the anonymous woman in the story on the wall

of the History Museum. When Sartre says that the café 'pursues its nihilation' he is describing a product of his own intentionality. But there is a real sense in which the German Pavilion may be said to pursue its own dematerialization in the specular qualities of its surfaces. These polished planes *induce* – as if in the electro-magnetic sense – the visitor's perpetual motion through its looped spaces. But unlike the café the pavilion offers an invariable material figure that detaches itself against the phenomenological drifting of the architectural ground. Kolbe's statue, beckoning as if at a rendezvous, catches the visitor's eye, and slows the sliding of meaning under the architectural signifiers.

Josep Quetglas has remarked that the visitor to the German Pavilion is 'beckoned on by an imaginary space which he will never enter'.[20] The imaginary space we can never occupy is the one we call 'the future'. In the 1950s, Mies van der Rohe pronounced that 'in the next ten years the best architecture will come from Spain' – a prediction best savoured in Barcelona while looking upon the dispiriting architectural legacy of the Franco years. Beatriz Colomina comments: 'In the Spain of Franco, Mies may have seen his dream realized: working for a totalitarian regime without renouncing the idiom of modern architecture, something that had proved impossible in Germany'.[21] In his proposals for the transformation of Berlin, Albert Speer recommended that buildings with an important symbolic function be built of materials that would superficially but rapidly deteriorate, clothing them in the timeless authority of the ruin.[22] A certain history was coming to an end in 1930, the year the German Pavilion was demolished. It began with the Enlightenment and passed through Goethe's Weimar and the Weimar Bauhaus. It is a history of political modernity, industrial modernization and aesthetic modernism: a history of 'progress'. In 1937, with the first aerial bombardment of a civilian population, the dream of progress was definitively shattered and the nightmare of modern warfare as universal mass terror began.[23] Whatever inhered in the original German Pavilion of the modernist dream of progress was demolished in 1930. Its copy could only ever be built as a ruin, a memorial, a mausoleum.

Benjamin believed that the role of the historian was to speak on behalf of the dead. Following their victory in 1939 the Nationalists pursued a politics of revenge. It is estimated that between 50,000 and 200,000 victims of summary executions lie in unmarked mass graves in Spain. Oral histories accumulated during years of official silence are now allowing the bone-pits to be located and excavated. There are no memorials to these victims of the Franco years, we must take our monuments where we find them. Beatriz Colomina has said that 'what counts' in Mies van der Rohe's buildings is their photographic image. The German Pavilion disappeared in 1930 to reappear in 1986. Photographs are the medium by which it travelled through time – a medium thick with images from the intervening years. Associations between images form like involuntary memories, at times in the form of involuntary memories, and solicit interpretation. In Classical antiquity, each oracular shrine had its own method of divination. Gods spoke through the rustle of leaves in a sacred grove, or through marks on the entrails of a sacrifice, or through the motions of objects cast into a pool. We may today see in these techniques a means of acknowledging what has been repressed, disavowed, foreclosed or otherwise elided. In Jacques Tati's film *Playtime* American tourists visit a Paris of modernist buildings indistinguishable from those of the cities they have left behind. On occasions we glimpse the Paris they have travelled

to see – the Sacré Coeur, the Eiffel Tower, the Arc de Triomphe – but only as fugitive reflections, slipping across the pivoting glazed surface of a window or a door, their spectral passing remarked only by the camera. In a television documentary about Catalonia and the Civil War, a young Republican volunteer swings a rifle over her shoulder and raises her arm to shade her face from the light. A tourist in Barcelona, lost in the German Pavilion, I glimpse the fleeting reflection of this image in the ambiguous planes where Kolbe's statue accompanies my own reflection. Josep Quetglas has written:

> An invisible occupant seems always to have left before the visitor arrived, and though he may be followed he will never be found. The visitor soon comes to the end of this off-putting, objectless labyrinth . . . when he realizes, in a flash of lucidity, that he is remembering what has been happening: it was he, erratic and disoriented, who has left each room in the very moment he himself had come in.[24]

To each oracular shrine its own method of divination. At some shrines, 'after the performance of preliminary rites, the consultant slept all night in the shrine and received a dream vision'.[25] On waking, the dream may be difficult to retain, for 'the day unravels what the night has woven'. We wake to find that 'the gods who live beneath the names and above places have gone off without a word and outsiders have settled in their place'. But involuntary recollection – a 'flash of lucidity' – can interrupt the blind repetition of the day's work with a time of reprise in which the night's weaving may be recovered, the old Maurelia reconnected with the new, the gods of history heard again.

Visitors to the German Pavilion walk on ancient lake beds. The paving is of Roman travertine limestone, quarried from lakeshores in the Tivoli region. The surface of the travertine is pitted with fissures caused during the stone's formation by gases from decaying vegetation; there are other traces of vegetation in carbonized and fossilized form. Some travertines house trilobite fossils from prehistoric

oceans. When the 1929 International Exhibition came to an end there were attempts to find a new use for Mies van der Rohe's German Pavilion. The failure of a scheme to turn it into a café led to the demolition of the building in 1930. Today there is debate over how the reconstructed pavilion should be used: as a reliquary for modernist architectural aesthetics, or as a platform for present cultural projects. But the pavilion proposes its own use – as one of those *lieux de mémoire* that Pierre Nora has described as 'moments of history torn away from the movement of history, then returned; no longer quite life, not yet death, like shells on the shore when the sea of living memory has receded'.[26]

6 Marker Marked

Following the initial credits sequence of Christ Marker's film *La Jetée*,[1] an intertitle emerges from black to announce:

This is the story of a man marked by an image from childhood.[2]

This screen of text is immediately followed by another that reads:

The scene that troubled him by its violence, and whose meaning he would understand only very much later, took place on the main pier of Orly, some years before the beginning of the Third World War.

These two screens of text are the only intertitles in the film, and together represent its kernel structure: an image, and a scene that contains it. They are the *mise-en-abyme* of the organization of the materials in which they are embedded: a succession of paused instants enchained within the movement of a narrative.

We subsequently learn that the image is of a woman's face:

and that the scene is of a man's death:

Cinema, Jean Cocteau remarked, 'films death at work'. It also awakens love. Chris Marker was born in 1921. Among the contents of his 1997 CD-ROM *Immemory*[3] is a sequence showing the actress Simone Genevoix in the 1928 film *La merveilleuse vie de Jeanne d'Arc*.[4]

Marker comments:

> It is this image that taught a child of seven how a face filling the screen was suddenly the most precious thing in the world, something which ceaselessly returned, which mingled with all the instants of life, such that repeating the name and describing the features to oneself became the most necessary and the most precious occupation – in a word, it taught the child what love is. The decipherment of these bizarre symptoms came later, at the same time as the discovery of cinema, so that for this grown up child, cinema and woman remained two absolutely insep- arable notions.[5]

In a publication of 1995 to accompany his video installation work *Silent Movie*, Marker says that he can only describe the effect that the image of Genevoix had on him in 'comic-strip onomatopoeias like "Wham!", "Thud-thud!", "Bump-bump!", "Shudder!"' This effect is subsequently displaced onto images of other women's faces: for ex- ample, the photographs in the 'Fées diverses' section of *Immemory*,

and the film clips in the 'Faces' section of *Silent Movie*. It also invests
the face of Hélène Chatelain that comes to haunt the child on the pier
at Orly.

La Jetée is the story of a man marked by an image from childhood, an
image abstracted from an action that contains it, like a frame taken
from a filmstrip. In 1907 Freud published an essay about Wilhelm
Jensen's short novel *Gradiva: A Pompeiian Fancy.*[6] The novella tells of
a young archaeologist who becomes fascinated by an antique relief of
a woman stepping forward. The man is obsessed with the question of
whether the woman's gait, the particular manner in which she steps
out – now immobilized in stone – could have been drawn from life or
whether it was entirely the invention of the artist. In the grip of his
obsession he searches amongst women who pass in the street for an
example of Gradiva's ambulatory manner – but without success. As
his obsession approaches delirium his investigations become a quest
for Gradiva herself. He dreams that he sees her at the moment of her
death, engulfed by the ancient eruption of Vesuvius which destroyed
Pompeii. He travels to the ruins of Pompeii. Alone in the ruined
streets he encounters what, in his disturbed state, he takes to be
Gradiva's ghost, walking with the step of the woman in the antique
relief. The 'ghost' in fact proves to be the young adult form of a long-

forgotten childhood playmate. She, who has neither forgotten nor stopped loving her lost friend, recognizes him right away. The rest of the tale is a story of how she coaxes him back to reality. Having regained his senses the man again falls in love with the girl, whom he had loved all along in the form of his 'Gradiva' delusion.

Jensen's story offers the *mise-en-scène* of an idea most succinctly expressed in the course of Freud's 'Three Essays on the Theory of Sexuality' of 1905: 'The finding of an object is in fact a refinding of it.'[7] Amongst the films that stage the finding of an object as a refinding is Alfred Hitchcock's *Vertigo*, which Marker names as pre-eminent amongst his three 'cult films'. In the part of *Immemory* where Marker describes the locations where *Vertigo* was shot, he writes: 'The section of sequoia is still at the entrance to Muir Woods . . . it had better luck than its counterpart in the Jardin des Plantes, today buried in a basement. (*Vertigo* could almost be remade using the same decors, unlike its remake in Paris).' Marker refers to *La Jetée* as a 'remake' of *Vertigo*. Both films in turn retell the Orpheus myth. The making of a story is always a remaking of it. In a 1950 review article about Jean Cocteau's film *Orphée*, Marker speaks of 'the very role of myth, which is that of refraction, of demultiplication'.[8] In the Classical myth, Orpheus leaves the world of the living to seek Eurydice amongst the ghosts in Hades. In *La Jetée*, the hero leaves his underground prison – a living hell – to seek the anonymous object of his desire in a sunlit world of

living ghosts: alive in their own time, dead in his own. The under-world of Classical cosmography exists simultaneously, in parallel with the world of the living. Orpheus and Eurydice are separated in space. The man and the woman in *La Jetée* are separated in time. In the French crime novel on which *Vertigo* is based – *D'Entres les morts*, by Pierre Boileau and Thomas Narcejac – the detective Flavière (Scottie) refers to Renée (Madeleine) as 'his Eurydice'. The woman in *La Jetée* calls the man 'her Ghost'. In the opening sequence of Marker's film *Sans soleil* a ferry carries a cargo of sleeping bodies across the water from Okaido to the other side. Wherever they are going, we know their ultimate destination.

In his review of *Orphée*, Marker pays tribute to Cocteau's use of everyday objects: objects that become – in Marker's expression – *objets jouant*, 'actor objects'. For Marker, the privileged example of the 'actor object' is the turnstile at the exit from the Hall of Mirrors through which Orson Welles passes at the end of *The Lady from Shanghai* – leaving the dying Rita Hayworth behind him. The turn-stile, Marker observes, allows only a one-way passage, making it clear that Welles will not return, *cannot* return. Welles does not look back. In Cocteau's *Orphée*, Marker finds such an object in the rearview mir-ror in which Orpheus inadvertently glimpses the face of Eurydice – irrevocably returning her to death. In *La Jetée* the scientists in the camp fix a mask over the eyes of the man for their experiment with time. Looking into this mask, the man sees his lover behind him in time. Cocteau's Orpheus sees his wife behind him in space. Marker comments: 'no further possibility of escape. This rear-view mirror is a trap laid by death.'[9]

Marker's epiphany in the movie theatre occurs during what he refers to, in *Immemory*, as his own 'funny kind of childhood'– caught between two wars.[10] He was nineteen years old at the time of the German occupation of Paris, and *Immemory* contains four short poems by one of his generation, by implication a friend, who did not return from deportation. Marker returns in memory to his first

love across the time of a catastrophe, just as the hero of Gradiva seeks the object of his desire on the other side of a devastating volcanic eruption, and the man in *La Jetée* must traverse the time of the Third World War. Just as the image of the woman's face is displaced throughout Marker's work, so the scene of the man's death is propagated in repeated citations of images of warfare. *La Jetée* was made in the year of the Cuban missile crisis. The film shows images of the nuclear ruins of Paris, of the devastation of buildings. In an essay about *La Jetée* Réda Bensmaïa remarks on the manifest absence of any images of the 'concrete effects that such a violent war has on human beings'.[11] Bensmaïa discovers these apparently missing images latent in the long lap dissolves, in which faces and bodies slowly decompose. Love is to be located on the other side of death, as the obverse of death: one is the 'flip side' of the other. In the diagesis of *La Jetée*, as in

the Orpheus myth, the man and the woman *pause* between life and death, just as the phenomenological appearances of the film hesitate between image and scene, immobility and motion. Such oscillations are supported by the inscription within the film of different registers of time.

Of the man's first meeting with the woman, the narrator says:

> She greets him without surprise. They are without memories, without projects. Their time constructs itself simply around them, with as sole points of reference the taste of the moment they are living, and the signs on the walls.

The time that constructs itself around the couple is that of *durée*, in Bergson's description: an indeterminate period of lived existence that may expand or contract according to the attention that is brought to it. In psychoanalytic terms, it is the time of the subject which, as Jean Laplanche puts it, 'secretes its own time' in memory and fantasy. Certain signs on the wall however point beyond this moment.

In a poem published in 1949, Marker writes:

> ... The people who make pallets
> to carry away the burned body of Yesterday
> have left chalk marks on the walls
> and we follow in their steps along the length of iron bridges[12]

This is a different kind of time, ticked off in chalk marks – like those on the walls of a prison cell – along the length of iron bridges, or of the main pier at Orly. This is the time of the living organism, the irreversible time of the entropic body. It is the time kept by biological clocks, the time of life spans. In a stilled moment the subject pauses between love and death:

The time of the human subject, *durée*, is embedded in the time of the human individual. This in turn is contained in the time of human generations, the time of societies, of the species; in short, 'history' – that 'march of time' that obsesses the filmmaker no less than Gradiva's step fascinated the archaeologist.

The image from childhood belongs to the register of subjective time, but in what modality? Marker says that his understanding of the bizarre symptoms of love 'came later'. The narrator of *La Jetée* tells us that the child on the pier understands 'much later' that he had seen a man die. It might seem that we are in the time of trauma – which in psychoanalytic terms obeys the retroactive temporality of 'after effect'. The narrator tells us:

Nothing distinguishes memories from other moments: it is only later that they make themselves recognized, by their scars.

But the emotional impact of the face of Simone Genevoix was felt immediately, and although the scene on the end of the pier troubles the child by its violence, the image of the face that haunts him does not traumatize. To the contrary, the narrator says that it accompanies the scene as if to render the scene more bearable:

> This face, which was to be the only image of peacetime to traverse the time of war, he long asked himself if he had really seen it, or if he had created this moment of gentleness to support the moment of madness which was to come.

The image of the woman at the end of the pier is not invested with affective significance after the event; its affect remains constant but it *insists*. A bright figure upon the shadowy ground of other memories, this image has all the attributes of a *screen memory*. In Freud's account, the screen memory, brilliant and enigmatic, dissimulates another memory, thought, fantasy – one that has had to be repressed. In *La Jetée* the image of the woman's face serves as a 'moment of gentleness' that distracts from, although it cannot conceal, a 'moment of madness'. The woman in the image, the woman the man subsequently encounters, is indeed a 'woman as image'. Alternately fully present and fully absent, like the object in the *fort/da* game, she is nothing other than that with which the man seeks to be (re)united. Making no demands of her own, compliant signifier of the man's desire, she is pure function: precipitating cause of the narrative. For both the man and for his torturers, all the mortified and somnambulistic movements of the underground prison camp come to turn around this single fixed point. The narrator tells us:

> This man was chosen from amongst a thousand, for his fixation on an image of the past.

The woman is the still centre of all narrative motion, and yet her image is the only one to move. In his monograph on Alain Resnais' film of 1962, *L'Année dernière à Marienbad*, Jean-Louis Leutrat makes reference to the widely commented moment in *La Jetée* when the sleeping woman wakes, an image unlike the others in that it contains the only 'real time' movement in a film otherwise composed entirely of stills.[13] He observes (my emphasis):

> In *L'Année dernière à Marienbad*, the couple formed by x and A are never physically reunited in real terms, apart from twice . . . , when x takes A in his arms . . . The tenderness and fluidity of these scenes contrast strongly with the distance and coldness of the other scenes. Marker was to imagine a similarly *fleeting moment of tenderness against a background of generalised immobility*.[14]

The real time movement as the woman opens her eyes is a 'fleeting moment' of live motion against a background of generalized immobility of the still images. The sequences of still images in which the woman appears represent fleeting moments of liberation against the generalized immobility of the man's living death in the camp. The man in *La Jetée* is doubly immobilized: as prisoner, and as experimental subject – his movements constrained by the hammock to which he is confined. The sentence spoken by the narrator immediately before the sequence in which we watch the woman sleeping is spoken over an image of the man who is himself apparently asleep:

> He never knows if he directs himself towards her, if he is directed, if he invents or if he is dreaming.

The word 'dreaming' fades as the image fades to black. Like the eponymous hero of George du Maurier's novel *Peter Ibbetson*, the 1935 film version of which was dear to André Breton, the man in *La Jetée* escapes prison through 'lucid dreams' in which he is reunited with the woman he loves while she sleeps and dreams as he does.[15]

La Jetée is the story of a man marked by an image from childhood, the image of the object from which the subject is separated and with which it strives to reunite. In a psychoanalytic perspective, the maternal body is the support of the prototype of this object. In considering the passage of the infant, and small child, into that differentiated world in which it exists separately from its mother, D. W. Winnicott formed the concept of the 'transitional object'.[16] Typically, the phenomenon of the 'transitional object' may be noted in the child's intense attachment to a corner of a blanket, or some preferred soft toy. Inevitably, something of the transitional phenomenon must inhere in an image. Winnicott extended his concept of transitional phenomena to include categories of both space and time. At the origin of the subject, in the relation of the infant to the mother, a time specific to the relationship is forged out of the asynchronous times of each, as each strives to reach accommodation with the asymmetrical desire of the other. It is this time that fills the temporal discontinuities in the relationship: a 'transitional time' comes into being that transforms the actual absence of the object-mother into a time of potential reunion, just as the transitional object reassures the child that the mother continues to exist even when she is not there. The privileged locus of this time is between external reality and dream: the time, for example, of the passage into sleep, or the time between sleep and waking, or day-dreaming, where real objects and internal objects mingle. This time is prospective, a movement into a future, a time of

creative anticipation. But what if the object is too long absent, or if on returning it repeatedly frustrates anticipation? What if, as the expression goes, 'nothing ever happens'? The answer of the French psychoanalyst André Green is that the transitional time of potential reunion is transformed into *le temps mort* – dead time – the temporal equivalent of empty space. In normal everyday experience this is the time of boredom, the waiting from which one expects nothing. At a pathological extremity it is the time of severe depression, in which the subject suffers a total inhibition of action and disinvestment from the world. Hard on the heels of such states, says Green, follow merciless attacks from the Super-Ego. The subject never feels that it has given up the world, but rather that it has been driven from it. As Green puts it:

> The retreat is in fact lived as if a third object has driven the subject from the scene. It is not I who absent myself; they do not want me to be here. I-they expel myself. Dead time is the time of death given or received.[17]

Winnicott said that, of the transitional object, we do not ask the question: 'Did you conceive of this or was it presented to you from without?' On the edge of sleep, the man in the hammock nevertheless asks himself whether he invents the woman, or whether he dreams her. We might ask ourselves whether he rather dreams the nightmare of the subterranean camp. His relationship with the woman gets nowhere. But it is not he who absents himself from her world. They do not wish him to have a place in it. He is expelled from lived time by an emissary from the camp, from the very locus of dead time – the time of prisoners with nothing to expect from life other than death.

The man and the woman sleep together. The man dreams the woman. The woman wakes to the man's nightmare. The sleep of reason engenders history, a history of stupidity and violence. As pessimism of the intellect deepens, optimism of the will decays. Revolutions

end in disappointment, or in tyranny. There is no longer anything to expect from history. Nothing will come of it. History itself becomes dead time. The narrator tells us:

> He saw a man without passion, who calmly explained to him that the human race was now condemned, that Space was closed to it, that the only possible relation with the means of survival passed by Time.

But time is closed if history has died. The only means of survival is to find an opening in space. In the opening sequence of his film *The Last Bolshevik* Marker traverses the revolutionary history of the twentieth century. As the sequence closes, and revolutionary history dies, Marker escapes by passing through the space between two fingers.

In *La Jetée* we must search in the space-time between two frames. Most of the transitions between images in *La Jetée* are cross-dissolves. Réda Bensmaïa sees entropy and abjection in the interim pictures generated by these transitions, others see hybrid creatures of myth. One dissolve suggests nothing out of the ordinary. It occurs unremarked in the most widely commented-on sequence in *La Jetée*, the one in which the sleeping woman wakes, a sequence unlike the others in that it contains the only 'real time' movement in a film otherwise composed entirely of stills. In the course of this sequence there is a dissolve

between two images of the woman's head on the pillow. Very little distinguishes one image from the other, except for the woman's lips: closed in the first image, parted in the second. The slow dissolve from one to the other produces another impression of real-time movement: a parting of the lips analogous to the opening of the eyes.

An opening of the body, a breath, perhaps a word, then vision. It is as if the moment of waking recognition has been unconsciously anticipated. As if the dream has prepared for waking into a world in which the most significant object is the one that has already been dreamt

La Jetée is the story of a man marked by an image from childhood. In the poem that Chris Marker published in 1949 we find the line: 'the wrists have in advance a hollow for the handcuffs'.[18] The poem is called *The Separated*. The line speaks of a mark that precedes any

inscription from childhood, a mark we are born with. The man in Marker's film *La Jetée* is haunted by the memory of a woman's face. The man in Jensen's story *Gradiva* is obsessed by the image of a woman's gait. Early in the tale, Jensen tells us that the man's father had, from the moment of his child's birth, decided on his son's choice of career. The father was an archaeologist whose ambition was that his son should achieve even greater recognition in the profession than he himself had done. Jensen tells us that only women of antique stone could now excite the young man, and that living women left him cold. No child could offer more convincing proof of submission to a parent's desire. The young archaeologist's obsessional interest in an antique relief proves to be motivated not only by an image from childhood, but also by his father's narcissism. His delirium shatters the grip of his father's obsession. It is implausible that there would be a detailed similarity between a living woman's gait and that depicted in an antique relief. But it was not necessary that the real woman's way of walking should really resemble that of the stone Gradiva. It was necessary only that the young man *see it as* similar. The formulation of such an equation, transforming petrification into desire, could not be achieved in waking logic, but only through the logic of the dream-work. History may mark us in advance with a hollow for the handcuffs, but the capacity to dream, to reconfigure the inherited world in terms of unforeseen and perhaps illegitimate relations, determines whether they will be worn.

Marker has said that *La Jetée* is a 'remake' of *Vertigo*. What for me is the most powerful and moving scene in Hitchcock's film begins with Scottie waiting in Judy's hotel room for her return from the hairdresser. She arrives dressed exactly as he had wished, with her hair now exactly the colour he had wanted, but a final step remains to achieve the death of Judy and the resurrection of Madeleine. He insists, against all her entreaties, that she put up her hair in a chignon, only then can the circle of the repetition of his desire be closed. But his insistence on repetition results only in the repetition of the death of his object. In

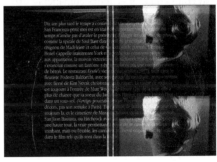

Sans soleil, Marker refers to 'Madeleine's hair, the spiral of time'. The spiral, however, is the image not of repetition but of *reprise*. The circle does not complete itself exactly, it reinscribes itself as differing from itself, and thereby defers closure. The type of criticism emerging in France at the time, *La Jetée* was made taught us to look at the work of art as a machine for generating meanings. Like the power supply that the people of the future give to the man to carry back to his own time, *La Jetée* has proved to be a compact and powerful generator of inexhaustible meanings. When the subject of *La Jetée* dies he does so not only under the eyes of the woman he loves, but under the eyes of himself as a child. One consequence that has been drawn from this much discussed temporal paradox is that the child will endlessly circle on a preordained journey through life to this particular fall at the end of a pier, much as the detective hero of *Vertigo* repeats his love affair as an

ineluctable return to a particular fall from the height of a tower. Marker calls *Vertigo* a 'cult film'. *La Jetée* also is a 'cult film'. A cult film is one that is viewed *repeatedly*. In 1974 the French film theorist Thierry Kuntzel made his first video. He rearranged the images of *La Jetée* into a different sequence, which he called *La Rejetée*. The pun in the title of Kuntzel's video condenses the ideas of redoing, rejecting and rethrowing (we might think of another throw of the dice). The video no longer exists, indeed it is not certain that it was ever completed, nevertheless the theoretician went on to successfully reinvent himself as a video artist. In 1972 Kuntzel had published his most significant theoretical essay. Entitled 'The film-work'[19] the essay brought a form of analysis based on Freud's idea of the 'dream-work' to a discipline then dominated by the linear models of linguistics. The dream, Freud insists, is not a narrative but a *rebus*, a picture puzzle that must be deciphered element by element. The linearity and narrative closure of *La Jetée* is only apparent, a contingent consequence of the conventional demand for a story with a beginning, a middle and an end when the spool of film runs out. The plurality of narratives that *La Jetée* generates are dreamed. A dream is a redistribution of the signifying elements of everyday existence under the impact of desire. It represents another throw of the dice. The narrator of *La Jetée* tells us 'there is no escaping time'. But we may add, with Jorge Luis Borges, 'Time forks perpetually towards innumerable futures'.[20]

7 Coda
Possessive, Pensive and Possessed

I began this book by suggesting that its object may exceed the grasp of theory. How can that 'of which we cannot speak' speak to theories of ideology? In the film studies reformation of the 1960s and '70s, film was seen as 'the product of the ideology of the economic system that produces and sells it'.[1] Much of what came after – first in film studies, then in photography studies – was in response to this initial proposition. In the intervening years the politics that framed the premise collapsed. In more recent years a re-engagement with film in terms of this premise has emerged in the work of the French philosopher Bernard Stiegler. Stiegler argues that the communality produced by the audio-visual industries to which cinema belongs results not in a 'we' (*nous*) – a collectivity of individual singularities – but in a 'one' (*on*), a de-individualized mass who come to share an increasingly uniform memory. For example, those who watch the same television news channel every day at the same time become, in effect, the same person – which is to say, according to Stiegler, *no one*.[2] He writes: 'Your past, support of your singularity . . . becomes the same past consciousness (*passé de conscience*) as the *one* who watches.[3] I began by talking about the various ways in which a film may be broken up, and its fragments dispersed throughout the environment in which we conduct our daily lives. Where subjective agency is involved, the subject corresponds to what Laura Mulvey has called the *possessive spectator*.[4] I went on to describe ways in which memory and fantasy weave these fragments into more or less involuntary reveries. The subject position here may be assimilated to what Mulvey, after Raymond Bellour, has called the

pensive spectator.[5] Bernard Stiegler warns that the fragment that haunts me may come to usurp me. To the 'possessive spectator' and the 'pensive spectator' we must add the category of the *possessed spectator*. Renewing Deleuze's vision of a 'society of control',[6] Stiegler's prospectus is bleak.

I believe Stiegler is both right and wrong in presenting the audio-visual industry as a totalizing and potentially totalitarian machine for the production of uniform consciousness. We must distinguish the political from the ideological. Stiegler is right in emphasising the extent to which industrially produced commodities have occupied not only real space but psychical space. At least one aspect of this – the issue of copyright – is political. As Colin MacCabe observes: 'in a world in which we are entertained from cradle to grave whether we like it or not, the ability to rework image and dialogue . . . may be the key to both psychic and political health'.[7] The same technology that has constructed the audio-visual machine has put the means of configuring its products into the hands of the audience. But when two-thirds of global copyrights are in the hands of six corporations,[8] the capacity to rework one's memories into the material symbolic form of individual testament and testimony is severely constrained. We rarely own the memories we are sold. Stiegler is wrong, however, to ignore the fact that whatever the audio-visual machine produces is destined to be broken up by associative processes that are only minimally conscious.[9] Although he makes liberal use of psychoanalytic terms, Stiegler uses neither the word 'preconscious' nor 'unconscious', speaking only of consciousness and 'consciousnesses' (a sort of 'collective conscious'). But the question of ideology is at least as much one of unconscious processes as it is of consciousness. Consciousnesses may be synchronized in a shared moment of viewing, but the film *we* saw is never the film *I* remember.

References

1 Introduction: The Noise of the Marketplace

1 Ludwig Wittgenstein, *Remarks on the Philosophy of Psychology* (Oxford, 1980), vol. I, Remark 257.

2 Raoul Ruiz, *Poétique du cinéma* (Paris, 1995), p. 58.

3 Roland Barthes, 'En sortant du cinéma', *Communications*, no. 23 (Paris, 1975), pp. 106–7.

4 Michel de Certeau, *L'Invention du quotidien: 1. arts de faire* (Paris, 1990), p. XL.

5 The term Barthes appropriates from Aristotle to denote 'Common Sense, Right Reason, the Norm, General Opinion'.

6 Repetition as a mode of spectatorship was established early in the history of cinema, in the 'continuous programming' that allowed spectators to remain in their seats as the programme of (typically) newsreel, 'short' and main-feature recycled. See Annette Kuhn, *An Everyday Magic: Cinema and Cultural Memory* (London, 2002), pp. 224–5. We may also think of typical forms of television spectatorship, with the broadcast film interrupted by such things as commercial breaks, telephone calls and visits to the kitchen.

7 Victor Burgin, *In / Different Spaces: Place and Memory in Visual Culture* (Berkeley and Los Angeles, 1996), pp. 22–3.

8 Francesco Casetti, *Theories of Cinema, 1945–1995* (Austin, TX, 1999), p. 316.

9 Michel Foucault, 'Of Other Spaces', *Diacritics*, XVI/1 (Spring 1986). Foucault's suggestive essay 'Des espaces autres' was originally given as a lecture in 1967 and he did not subsequently review it for publication. Many of the ideas in it remain undeveloped, and my own use of them here is partial.

10 In their relation to time, Foucault says, heterotopias 'open onto what might be termed, for the sake of symmetry, heterochronies'. He gives the contrasting examples of the archive and the festival: the former representing an accumulation of times, the latter representing time at its most fleeting. The Internet offers both an archive and a site of transient instantaneous events.

11 Roland Barthes, *Le Plaisir du texte* (Paris, 1973), p. 67, my translation; *The Pleasure of the Text* (New York, 1975), p. 49.

12 *Ibid.*

13 *Le Plaisir du texte*, p. 68, my translation; *The Pleasure of the Text*, p. 49.

14 *Le Plaisir du texte*, p. 67, my translation; *The Pleasure of the Text*, p. 49.

15 Lev Vygotsky, *Thought and Language* (Cambridge, MA, 1977), p. 139.

16 *Ibid.*, p. 148.

17 'If a dream is written out it may perhaps fill half a page. The analysis setting out the dream-thoughts underlying it may occupy six, eight or a dozen times as much space'; Sigmund Freud, 'The Interpretation of Dreams', in *The Standard Edition of the Complete Psychological Works of Sigmund Freud*, trans. and ed. James Strachey, 24 vols (London, 1955–74), vol. IV.

18 Arthur Schnitzler, *Traumnovelle* (1926), trans. as *Dream Story* (London, 1999).

19 I first heard this term from David Rodowick.

20 There are sites devoted entirely to QuickTime files of film trailers.

21 The student was Jennifer Ringley, then in her final year at Dickinson College, Pennsylvania. If Ringley had presented her work in the context of the 'art world' she would certainly have become famous as an artist, but the Internet is not a sacralized space.

22 Paul Brown, 'why it's of interest', http://www.artTech.ab.ca/pbrown/jenni/whyJenni.html

23 What – for convenience, or from habit – we call 'inner' and 'outer' worlds are mutually implicated with such intricacy that any use of the distinction here must be considered 'under erasure'. For a discussion of the problems engendered by the dichotomy 'inside'/'outside', see Darian Leader, 'The Internal World', in *Freud's Footnotes* (London, 2000).

24 'Ça' is the standard French translation of Freud's 'Es', rendered in English as 'Id'.

25 Jean Laplanche and Serge Leclair, 'The Unconscious: A Psychoanalytic

Study', *Yale French Studies*, no. 48 (1972), pp. 162–3.

26 'Topographically', the fantasy may be conscious, preconscious or unconscious. It is encountered, says Freud, 'at both extremities' of the dream – in the secondary elaboration of the dream as consciously narrated, and in the most primitive latent contents. The daydream is somewhere between the two.

27 Jean Laplanche and J.-B. Pontalis, *The Language of Psycho-Analysis* (London, 1973), p. 316. They continue: 'It is possible to distinguish between several layers at which phantasy is dealt with in Freud's work: conscious, subliminal and unconscious. Freud was principally concerned however less with establishing such a differentiation than with emphasising the links between these different aspects.'

28 See, for example, Roland Barthes, 'The Sequences of Actions' (1969), in *The Semiotic Challenge* (New York, 1988), p. 141, and *S/Z* (1970), trans. Richard Miller (London, 1975), p. 204.

29 *Listen to Britain*, shown in the context of 'Listen to Britain: Works by Victor Burgin', Arnolfini, Bristol, September–November 2002. See Victor Burgin, Stephen Bann, Peter Osborne, Françoise Parfait and Catsou Roberts, *Relocating* (Bristol, 2002).

30 What I characterize here as 'brilliance' is a characteristic of the 'psychical intensity' of the 'screen memory'. See the Editor's Appendix, *Standard Edition*, vol. III, pp. 66ff., for a discussion of Freud's use of the expression 'psychical intensity', and Freud's essay 'Screen Memories' (1899), in *ibid.*, vol. III, pp. 311–12.

31 Pierre Nora, 'Between Memory and History: Les lieux de mémoire', *Representations*, no. 26 (Spring 1989), p. 7.

32 *Ibid.*, p. 12.

33 See, for example, Hollis Frampton's film *A Casing Shelved*, which consists of a static shot of a bookcase, and the photographs in Edweard Muybridge's *Animal Locomotion*.

34 Hollis Frampton, 'For a Metahistory of Film: Commonplace Notes and Hypotheses' (1971), in *Circles of Confusion: Film, Photography, Video: Texts, 1968–1980* (Rochester, NY, 1983), p. 114.

35 André Kertèsz, *On Reading* (New York, 1971).

36 Peter Wollen, 'Fire and Ice', *Photographies*, no. 4 (April 1984).

37 Other, very different, examples are provided by Hollis Frampton's film *Nostalgia*.

38 See Raymond Bellour, 'The Pensive Spectator', *Wide Angle*, IX/1 (1987), and Laura Mulvey, 'The "Pensive Spectator" Revisited: Time and its Passing in the Still and Moving Image', in *Where Is the Photograph?*, ed. David Green (Brighton, 2003).

39 Roland Barthes, 'Introduction to the Structural Analysis of Narratives' (1966), in *Image – Music – Text* (New York, 1977), p. 79.

40 Roland Barthes, 'The Sequences of Actions' (1969), in *The Semiotic Challenge*, p. 141.

41 *Ibid.*, p. 139.

42 Norman Bryson, *Word and Image: French Painting of the Ancien Régime* (Cambridge, 1981), p. 85.

43 Maurice Merleau-Ponty, *Causeries 1948* (Paris, 2002), p. 21.

44 Ludwig Wittgenstein, *Tractatus Logico Philosophicus* (London, 1961), p. 7.

45 Roland Barthes, 'Le mythe, aujourd'hui', in *Mythologies* (Paris, 1957), p. 247; trans. in *Mythologies* (New York, 1979), p. 159.

46 Casetti, *Theories of Cinema*, p. 316

2 Barthes' Discretion

1 Hollis Frampton, 'For a Metahistory of Film: Commonplace Notes and Hypotheses' (1971), in *Circles of Confusion: Film, Photography, Video: Texts, 1968–1980* (Rochester, NY, 1983), p. 116.

2 John Donne, 'Loves Diet', in *The Complete Poetry of John Donne* (New York, 1967), p. 135.

3 Jean-Luc Godard, *La Paresse*, episode of *Sept péchés capitaux* (1961); Eddie Constantine (Eddie Constantine), Nicole Mirel (the Starlet). (Other episodes by Claude Chabrol, Édouard Molinaro, Jacques Demy, Roger Vadim, Philippe de Broca and Sylvain Dhomme.)

4 Alain Bergala, note on 'La Paresse' in *Cahiers du Cinéma, Spécial Godard: trente ans depuis* (Paris, 1990), p. 114.

5 Christian Metz, 'Le film de fiction et son spectateur', in *Communications*, no. 23 (Paris, 1975), p. 119.

6 Roland Barthes, 'En sortant du cinéma', in *Communications*, no. 23 (Paris, 1975), pp. 104–7.

7 *Ibid.*, p. 104.

8 Roland Barthes, 'Diderot, Brecht, Eisenstein', in *Image – Music – Text*

(New York, 1977).

9 *Ibid.*, pp. 76–7.

10 *Ibid.*, pp. 71–2

11 Barthes, 'En sortant du cinéma', p. 106.

12 *Ibid.*, p. 104. Breuer and Freud refer to 'the semi-hypnotic twilight state of day-dreaming, auto-hypnoses, and so on', in *The Standard Edition of the Complete Psychological Works of Sigmund Freud*, trans. and ed. James Strachey, 24 vols (London, 1955–74), vol. II, p. 11.

13 Barthes, 'En sortant du cinéma', pp. 105–6.

14 Barthes plays on various senses of the verb *décoller*, which can mean not only to 'unstick' but also to 'take off' (in the aeronautical sense) and to 'get high' (in the drug-use sense).

15 Barthes, 'En sortant du cinéma', pp. 106–7.

16 *Ibid.*, p. 106.

17 Giuliana Bruno, *Streetwalking on a Ruined Map: Cultural Theory and the City Films of Elvira Notari* (Princeton, NJ, 1993), chapter 3.

18 Barthes, 'En sortant du cinéma', p. 105.

19 Roland Barthes, 'Au palace ce soir', in *Incidents* (Paris, 1987), p. 65.

20 *Ibid.*, p. 68.

21 Roland Barthes, *Le Plaisir du texte* (Paris, 1973), p. 19.

22 Charles Baudelaire, 'The Painter of Modern Life', in *The Painter of Modern Life and Other Essays* (New York, 1978), p. 10.

23 Roland Barthes, *Roland Barthes par Roland Barthes* (Paris, 1975), p. 98.

24 Barthes, *Incidents*, p. 86.

25 In French, a *lieu commun* is a platitude (cf. English: 'commonplace'); at the same time, taken word for word, it may mean 'common place', in the sense of ' public space'.

26 Barthes, *Incidents*, p. 104.

27 See Victor Burgin, 'Diderot, Barthes, *Vertigo*', in *The End of Art Theory: Criticism and Postmodernity* (London, 1986).

28 Roland Barthes, *La Chambre claire* (Paris, 1980), p. 177.

29 *Ibid.*, p. 181.

30 *Ibid.*, p. 181.

31 *Ibid.*, p. 177.

32 Barthes, *Roland Barthes par Roland Barthes*, p. 90

33 Barthes, *La Chambre claire*, p. 13.

34 Barthes, 'En sortant du cinéma', p. 106.

35 Roger Caillois, *Méduse et Cie* (Paris, 1960), pp. 71ff.

36 Jacques Lacan, *Le Séminaire, livre XI: Les quatres concepts fondamentaux de la psychanalyse* (Paris, 1973, from a seminar given in 1964), p. 98.

37 *Ibid.*, p. 99.

38 *Ibid.*

39 Christian Vincent, *La Discrète* (1990), with Fabrice Luchini and Judith Henry.

40 Lacan, *Le Séminaire, livre XI*, p. 104.

41 Siegfried Wenzel, *The Sin of Sloth: Acedia in Medieval Thought and Literature* (Chapel Hill, NC, 1960).

42 *Ibid.*, pp. 13–14.

43 *Ibid.*, p. 35.

44 Barthes, *Incidents*, p. 87.

45 *Ibid.*, p. 87.

46 Metz, 'Le film de fiction et son spectateur', p. 112.

47 Barthes, 'En sortant du cinéma', p. 107.

48 Barthes, *Le Plaisir du texte*, p. 30.

49 Freud, *Standard Edition*, vol. VI, pp. 140, 142, 150.

50 Lacan, *Le Séminaire, livre XI*,, p. 53.

51 *Ibid.*, p. 55.

3 Jenni's Room: Exhibitionism and Solitude

1 See James Baldwin, *Giovanni's Room* (New York, 1956).

2 In 1996 Jennifer Ringley was in her final year at Dickinson College, Pennsylvania, where she had majored in economics and had developed a strong interest in webpage design. Here is how she described the technique: 'I use Timed Video Grabber to catch a picture from my Connectix QuickCam every minute. Every three minutes QuickKeys executes an AppleScript which tells Fetch to upload the picture . . . And the server sends it to you!' (JenniCam homepage: www.boudoir.org. The site subsequently changed address to www.jennicam.org).

3 Ringley, JenniCam homepage. In June 1997 this became a pay site. Jenni wrote: 'I hope you understand how much I hate doing this. I feel like I'm letting everyone down. I feel like a traitor. I hope you believe me when I say that if there were any other way to do this, I'd be doing it. The

fundamental problem is that we originally estimated bandwidth costs at around $200 a month. We thought we could take an advertiser to cover it, but things fell through and nothing materialized. And then we found out that our monthly cost ran way over $1,000 for the month.' After more than seven years online, the Jennicam site closed on 31 December 2003.

4 Jere Downs, 'The JenniCam Ensnares Online Fans into her Web: She Bares her Life on the Net', *Philadelphia Inquirer*, 6 July 1997, p. A1; my emphasis.

5 Bruce Haring, 'Net Cameras Put Intimacy Online', USA *Today*, 8 April 1998, p. 5D.

6 Freud remarks: 'Every active perversion is . . . accompanied by its passive counterpart: anyone who is an exhibitionist in his unconscious is at the same time a *voyeur*'; Sigmund Freud, 'Three Essays on the Theory of Sexuality' (1905), in *The Standard Edition of the Complete Psychological Works of Sigmund Freud*, trans. and ed. James Strachey, 24 vols (London, 1955–74), vol. VII, p. 167.

7 The developers of *CU-SeeMe* write: 'multiple parties at different locations can participate in a *CU-SeeMe* conference, each from his or her own desktop computer'. The images broadcast by means of this 'video-conferencing' programme are often scenes of masturbation.

8 I would emphasize that I know Jennifer Ringley only as Jenni – a multi-media construct, a collage of words and images. This Jenni is no more or less real than James Baldwin's Giovanni. In what follows I make no pretence to 'psychoanalyse' Ringley; this would be patently absurd. The Jenni I speak of here is not a person to be psychoanalysed but a heuristic device in a discourse about images. The real Jennifer Ringley has observed: 'I have two personalities. There's Jennifer, who nobody is interested in. And there's Jenni' (Downs, 'The JenniCam, p. A).

9 Ringley, interview with Ira Glass, 'Tales from the Net', *This American Life*, 6 June 1997, WBEZ-FM Chicago, 91.5. See also the singer / songwriter Ana Voog's comment: 'If you wake up in the middle of the night or something with an anxiety attack, it's really nice to know people from all over the world are all there, to comfort you or talk about anything you want. It's just really cool.' (Haring, 'Net Cameras Put Intimacy Online').

10 See Jacques Lacan, 'The Mirror Stage as Formative of the Function of the I as Revealed in Psychoanalytic Experience' (1949), in *Ecrits: A Selection*

(New York, 1977), pp. 1–7. Mirrors make various appearances in the writings of psychoanalysts. Freud spoke metaphorically when he recommended that the analyst be a 'well polished mirror' for his patient. Otto Fenichel spoke of real mirrors when he observed that the mirror, in confronting the individual with his or her own body in an external form, obliterates 'the dividing-line between ego and non-ego'; Otto Fenichel, 'The Scoptophilic Instinct and Identification' (1935), in *The Collected Papers of Otto Fenichel, First Series*, ed. Hanna Fenichel and David Rapaport (New York, 1953), p. 376. Psychoanalysts have also taken note of the ways in which the mirror figures in fields of enquiry outside psychoanalysis. For example, the Hungarian psychoanalyst Géza Roheim wrote a book on 'looking-glass magic' that draws extensively on his original training as an anthropologist. In Lacan's essay the mirror appears both as metaphor and as objective reality, and there are references to such disciplines beyond psychoanalysis as entomology, ethology and empirical studies of child behaviour.

11 D. W. Winnicott, 'Mirror-role of Mother and Family in Child Development' (1967), in *Playing and Reality* (Harmondsworth and New York, 1982), p. 130.

12 For example, Lacan refers to the mural paintings in the great hall of the Doge's Palace in Venice and asks: 'Who comes to these places? Those who form . . . *the people*. And what do the people see in these vast compositions? The gaze of those persons who – when they are not there, they the people – deliberate in this hall. Behind the painting, it is their gaze which is there'; Jacques Lacan, *Le Séminaire, livre XI: Les quatres concepts fondamentaux de la psychanalyse* (Paris, 1973, from a seminar given in 1964), p. 104. In such terms there is some foundation to a widespread tendency in film and photography theory to assimilate considerations of the gaze to Foucault's notion of panopticism. (I first criticized this tendency in 'Geometry and Abjection', *AA Files: Annals of the Architectural Association School of Architecture*, no. 15, Summer 1987.) Much of what Lacan says about the gaze in *Seminar XI* (1964) is fundamentally similar to what he said in *Seminar I* (1953) – apart from an important difference of emphasis derived from a shift from Sartre's phenomenology to that of Merleau-Ponty. What is radically different in the seminar of 1964 is Lacan's reformulation of the gaze as *objet petit a*, as cause of desire.

13 When, in 1953, Lacan revised his idea of the mirror stage to take account

of the presence of the (m)other alongside the child, it was primarily the (m)other's voice that was at issue: in confirming, denying or imposing the child's imaginary identifications (e.g., 'Yes, that's you, aren't you a little princess!' Or, 'Yes, you have your father's eyes'). The (m)other is here an agent of the Symbolic.

14 Winnicott, 'Mirror-role', p. 131.

15 The French term *regard* is used by Lacan and by Sartre in the work on which Lacan initially drew. In English translations of these writers the word has been translated alternately as 'look' and 'gaze'. It is tempting (a temptation that I have nevertheless resisted) to use only the English word *regard* when discussing the ideas of Winnicott – because of its capacity simultaneously to connote elements of *look, care* and *esteem*.

16 Winnicott, 'Mirror-role', p. 134.

17 *Ibid.*, p. 133 (Winnicott quotes the writer Francis Bacon: 'A beautiful face is a silent commendation').

18 Downs, 'The JenniCam', p. A1.

19 According to Winnicott, part of the mother's early role is to instil a sense of omnipotence in the infant by providing its objects there at the moment and in the place where it hallucinates them. The primary example of this is when the mother anticipates the infant's need for the breast and provides it more or less where and when the infant tries to summon it into being. Infantile omnipotence is the origin of the confidence with which the child will later explore the world once it has come to distinguish between its body and its objects.

20 See Didier Anzieu, *The Skin Ego* (New Haven and London, 1989). Catherine Clément succinctly characterizes the mirror stage as 'the moment when one becomes oneself because one is no longer the same as one's mother'; Catherine Clément, *The Lives and Legends of Jacques Lacan* (New York, 1983), p. 76.

21 Winnicott writes: '*Of the transitional object it can be said that it is a matter of agreement between us and the baby that we will never ask the question: "Did you conceive of this or was it presented to you from without?" The important point is that no decision on this point is expected. The question is not to be formulated*' (italics in original); D. W. Winnicott, 'Transitional Objects and Transitional Phenomena', in *Playing and Reality*, p. 14.

22 D. W. Winnicott, 'Playing: A Theoretical Statement', in *Playing and Reality*, p. 55.

23 *Ibid.*, pp. 55–6.

24 D. W. Winnicott, 'The Capacity to be Alone' (1958), in *The Maturational Processes and the Facilitating Environment* (London, 1965), p. 30.

25 For a Winnicottian perspective on adolescence and risk-taking, see Adam Phillips, 'On Risk and Solitude', in *On Kissing, Tickling and Being Bored* (Cambridge, MA, 1993).

26 We need not necessarily decide between these explanations: it may be significant that we speak of 'exposing ourselves' to risk.

27 Downs, 'The JenniCam', p. A1.

28 Winnicott, 'Playing', p. 60.

29 See Jean Laplanche, 'The Drive and its Object-Source: Its Fate in the Transference', in *Jean Laplanche: Seduction, Translation, Drives* (London, 1992), p. 189

30 Downs, 'The JenniCam'.

31 Winnicott, 'Playing', p. 55.

32 A message posted on the Internet requests images of Jenni's room to the left and right of her bed. The person posting the request is attempting to construct a panoramic image of the room.

33 A number of commercial 'pay sites' have sprung up in emulation of the JenniCam. The activities of these self-professed 'amateur models' are exclusively sexual and the details they give of their lives are patently fictional. The appeal to simple sexual voyeurism here is unambiguous. The voyeurisms to which Jenni appeals are no less a complex amalgam of sexual and sublimated elements than is her purported exhibitionism.

34 Roland Barthes, *The Pleasure of the Text* (New York, 1975), pp. 9–10.

35 Sigmund Freud, *Beyond the Pleasure Principle* (1920), in *Standard Edition*, vol. XVIII, pp. 14ff.

36 Katherine Philips, 'Solitude', in *Poems* (London, 1667), p. 171.

37 See Francette Pacteau, 'The Imaginary Companion', in *The Symptom of Beauty* (Cambridge, MA, 1994), chapter 2.

38 In a Lacanian perspective it might serve as exemplar of the 'gaze as *objet petit a*' – a split off and mobile part object.

39 Downs, 'The JenniCam'.

40 Melanie Klein 'On the Sense of Loneliness', in *Our Adult World* (London, 1963).

41 James Baldwin, *Giovanni's Room* (New York, 1956), pp. 112–13.

4 The Remembered Film

1 In the original title of *Vive l'amour* – *Aiqing wansui* – there is an ambivalence of meaning between 'love' and 'affection'. My thanks to Tatsuya Matsumura for telling me this.

2 Roland Barthes, *Camera lucida* (1980), trans. Richard Howard (New York, 1982), p. 53.

3 Sigmund Freud, 'Hysterical Phantasies and their Relation to Bisexuality' (1908), in *The Standard Edition of the Complete Psychological Works of Sigmund Freud*, trans. and ed. James Strachey, 24 vols (London, 1955–74), vol. IX, p. 160.

4 See André Green, 'Conceptions of Affect', in *On Private Madness* (London, 1986).

5 We might more accurately say 'suppressed' since Barthes is himself able to recover the idea from the preconscious.

6 See Elizabeth Cowie, 'Fantasia', *m/f*, no. 9 (1984).

7 Serge Leclaire, *Psychanalyser: un essai sur l'ordre de l'inconscient et la pratique de la lettre* (Paris, 1968), p. 99, my translation; *Psychoanalyzing: On the Order of the Unconscious and the Practice of the Letter* (Stanford, CA, 1988), p. 70.

8 Leclaire, *Psychoanalyzing*, p. 83.

9 Freud himself was led, in considering hypochondria, to extend the concept of 'erotogenic zone' even to the internal organs. See 'On Narcissism: An Introduction' (1914), in *Standard Edition*, vol. XIV, p. 84.

10 In conversation with Anika Lemaire, quoted in Anika Lemaire, *Jacques Lacan* (London, 1977). The letter belongs to the register of the imaginary. It is in the nature of an image, whether the image in question be visual, or tactile, kinaesthetic, olfactory, auditory, phonemic or monemic. What is essential in the letter is that it is the primitive representative of loss, derivative of the auto-erotic satisfactions of primary narcissism. In a Lacanian perspective it represents the 'alienation of the instinct in the signifier'. It is what Leclaire and Laplanche elsewhere call the 'elementary signifier' of the unconscious, an object of what Freud called 'primal repression'.

11 Jean Laplanche and Serge Leclaire, 'The Unconscious: A Psychoanalytic Study' (1960), *Yale French Studies*, no. 48 (1972).

12 *Ibid.*, p. 135.

13 'Observation shows that dreams are instigated by residues from the

previous day – thought-cathexes which have not submitted to the general withdrawal of cathexis, but have retained in spite of it a certain amount of libidinal or other interest . . . In analysis we make the acquaintance of these "day's residues" in the shape of latent dream-thoughts; and, both by reason of their nature and of the whole situation, we must regard them as preconscious ideas, as belonging to the system Pcs'; Sigmund Freud, 'A Metapsychological Supplement to the Theory of Dreams' (1917 [1915]), in *Standard Edition*, vol. XIV, p. 224.

14 D. W. Winnicott, 'Transitional Objects and Transitional Phenomena', in *Playing and Reality* (Harmondsworth and New York, 1982), p. 30.

15 D. W. Winnicott, 'The Location of Cultural Experience', in *Playing and Reality*, pp. 11 ff.

16 Roland Barthes, 'The Third Meaning' (1970), in *Image – Music – Text* (New York, 1977).

17 *The Cableguide*, November 1999.

18 Dir. Robert Parrish, 1957.

19 An archive that in principle includes even films unseen. For example, amongst the one-liners in the 'F' section of *The Cableguide*, I also read: '*For Your Eyes Only* (1981) James Bond (Roger Moore) races Russians to a sunken spy ship'; and, '*Forever Young* (1992) A test pilot (Mel Gibson), frozen in the 30s, thaws out in the 90s'. I have not seen either of these two films, but I already know the story of each – that is to say I know the underlying story (*histoire*) that will vary only in the telling (*récit*). 'James Bond races Russians to a sunken spy ship' is simply another variant alongside 'Captain Courageous races pirates to a buried treasure'. Similarly, the frozen Mel Gibson thawing out in the 1990s is an updated variant of Rip Van Winkle.

20 Marie-Claude Taranger, 'Une mémoire de seconde main? film, emprunt et référence dans le récit de vie', *Hors Cadre*, 9 (1991).

21 *Ibid.*, pp. 55–6.

22 In the most common type of screen memory discussed by Freud an early memory is concealed by the memory of a later event. It is possible for an earlier memory to screen a later one. Freud also remarks on a third type, 'in which the screen memory is connected with the impression that it screens not only by its content but also by contiguity in time: these are contemporary or contiguous screen memories'; Sigmund Freud, 'The Psychopathology of Everyday Life' (1901), in *Standard Edition*, vol. VI, p. 44.

23 From the *American Heritage Dictionary*.
24 Freud writes: 'It may indeed be questioned whether we have any memories at all from our childhood: memories relating to our childhood may be all that we possess. Our childhood memories show us our earliest years not as they were but as they appeared at the later periods when the memories were aroused. In these periods of arousal, the childhood memories did not, as people are accustomed to say, emerge; they were formed at that time. And a number of motives, with no concern for historical accuracy, had a part in forming them, as well as in the selection of the memories themselves'; Sigmund Freud, 'Screen Memories' (1899), in *Standard Edition*, vol. III, p. 322.
25 See D. W. Winnicott, 'The Use of an Object and Relating through Identifications', in *Playing and Reality*, pp. 101ff.

5 Mies in Maurelia

1 Italo Calvino, *Invisible Cities* (San Diego, New York and London, 1974), pp. 30–31.
2 The German Pavilion was opened on 27 May 1929, and demolished in January 1930.
3 Georg Kolbe, *Der Morgen* (1925). The literal English translation of the title of this work is of course 'Morning'. However, 'Sunrise' – and occasionally 'Dawn' – has become the most widely adopted English title. The original statue now stands in the gardens of the Schöneberg Town Hall in Berlin.
4 Schloss Ettersburg, the home of Goethe's patron, the Duke of Saxony.
5 See Sven Lindqvist, *A History of Bombing* (London, 2001), sections 156ff.
6 Beatriz Colomina, 'Mies Not', in *The Presence of Mies*, ed. Detlef Mertins (New York, 1994), p. 213.
7 Peter Blake, *Mies van der Rohe: Architecture and Structure* (London, 1960), p. 54.
8 Mies van der Rohe, in *Mies van der Rohe: Less is More*, p. 146.
9 Josep Quetglas, *Fear of Glass* (Basel, Boston, MA, and Berlin, 2001), p. 37.
10 Shaftesbury, 'The Moralists', Part III, Section II, in A. Hofstadter and R. Kuhns, *Selected Readings in Aesthetics from Plato to Heidegger* (Chicago, 1964), pp. 245–6.

11 About half-a-million surviving Republicans went into exile, many of them ending in camps in the South of France. In Spain the repression continued with executions, imprisonment and forced labour. See 'L'Espagne y va Franco: le pays exhume ses années de dictature', *Libération*, 25 February 2003, pp. 14–15.

12 A commission for a retrospective exhibition of my work at the Tàpies Foundation. See Norman Bryson *et al.*, *Victor Burgin*, Barcelona, Fundació Antoni Tàpies (2001).

13 Jean Laplanche, 'Le temps et l'autre', *Psychanalyse à l'Université*, XVI/61 (January 1991), pp. 47ff.

14 Quoted in Germaine de Bissy, 'La remémoration chez Marie Bonaparte et ses cinq cahiers', *Revue Française de la Psychanalyse*, LIV/4 (July–August 1990), p. 1068.

15 Walter Benjamin, 'The Image of Proust', in *Illuminations* (London, 1973), p. 198.

16 J.-B. Pontalis, 'ÇA en lettres capitales', in *Ce temps qui ne passe pas* (Paris, 1997), p. 115.

17 As if, this is to say, my involuntary recollection had taken the form of the defence mechanism that Freud named *disavowal*.

18 Jean-Paul Sartre, *L'Etre et le néant* (Paris, 1943), pp. 43–4; trans. as *Being and Nothingness* (New York, 1956), pp. 40–42.

19 Sigmund Freud, 'A Disturbance of Memory on the Acropolis' (1936), in *The Standard Edition of the Complete Psychological Works of Sigmund Freud*, trans. and ed. James Strachey, 24 vols (London, 1955–74), vol. XXII, p. 241.

20 Quetglas, *Fear of Glass*, p. 92.

21 Beatriz Colomina, 'Mies Not', p. 202.

22 See Francesco Dal Co and Sergio Polano, 'An Interview with Albert Speer', in *Oppositions*, XXII (Spring 1978), pp. 41–52.

23 I take the deliberate targeting of civilians as the turning point. The First World War invented modern warfare as we know it, but within the old imaginary space of conflict between opposing professional armies.

24 Quetglas, *Fear of Glass*, p. 133.

25 *The Oxford Classical Dictionary* (Oxford, 1970), p. 754. The technique of 'incubation' – sleeping within the precincts of a temple – was mainly practised at shrines devoted to healing, but it could also be used to find lost objects, or receive information. Some temples had resident dream interpreters.

26 Pierre Nora, 'Between Memory and History: *Les Lieux de mémoire*', *Representations*, 26 (Spring 1989), p. 12.

6 Marker Marked

1 *La Jetée*, dir. Chris Marker, prod. Anatole Dauman, Argos Films, 1962 (released 1964), black and white, 28 min.
2 'Ceci est l'histoire d'un homme marqué par une image d'enfance'; in spoken French, the proximity of *marqué* to *Marker* is very apparent.
3 *Immemory* (Paris, Centre Georges Pompidou, 1997).
4 Dir. Marc de Gastyne, 1928.
5 Marker re-tells the same anecdote in a publication of 1995 to accompany his video installation work *Silent Movie*: '*Wings* is certainly not the first picture I saw: it's the first I remember . . . Next came Gastyne's Joan of Arc and the close-ups of Simone Genevoix. It was probably the first time I saw a dame's face enlarged on a 44 × 33-ft screen (even Clara Bow didn't attain such proportions) but I don't think this quantitative phenomenon explains by itself the state of exhilaration I found myself in. I couldn't describe it otherwise that with comic-strip onomatopoeias like "Wham!", "Thud-thud!", "Bump-bump!", "Shudder!" – another way to put sound on film, mostly indecipherable for a seven-year-old boy, but which I identified clearly, later on, as the true symptoms of Romance. And when some years ago the French Cinémathèque issued a beautifully restored copy of *La merveilleuse vie de Jeanne d'Arc*, I found myself sitting not far from a charming old lady, who didn't suspect for one minute she had been, literally, my first love' (Chris Marker, 'The Rest is Silent', in *Chris Marker: Silent Movie*, Wexner Center, Ohio State University, 1995). In his CD-ROM work *Immemory* he adds that he: '. . . suddenly felt towards her that wave of tenderness which comes to old lovers when chance brings them together after many years of separation' (*Immemory*, Paris, Centre Georges Pompidou, 1997).
6 Sigmund Freud, 'Delusions and Dreams in Jensen's *Gradiva*' (1907 [1906]), in *The Standard Edition of the Complete Psychological Works of Sigmund Freud*, trans. and ed. James Strachey, 24 vols (London, 1955–74), vol. IX, pp. 1–95. Wilhelm Jensen, *Gradiva: A Pompeiian Fancy* (1903), trans. in S. Freud, *Delusion and Dream* (Boston, 1956), pp. 147–235.

7 Sigmund Freud, 'Three Essays on the Theory of Sexuality' (1905), in *Standard Edition*, vol. VII, p. 222.

8 Chris Marker, 'Orphée', *Esprit*, 18 (11 November 1950), p. 695.

9 *Ibid.*, p. 697.

10 'Drôle d'enfance, calée entre deux guerres commes un livre coincé entre deux éléphants de bronze' (*Immemory*, Paris, Centre Georges Pompidou, 1997).

11 Réda Bensmaïa, 'From Photogram to Pictogram', *Camera Obscura*, no. 24 (1990), p. 152.

12 '. . . Les gens qui font des claies / pour emporter d'ici le corps brûlé d'Hier / ont laissé sur les murs des marques à la craie /et nous suivons leurs pas le long des ponts de fer'; Chris Marker, 'Lés séparés', *Esprit*, 17 (12 December 1949), pp. 921–3.

13 In Resnais' film the central characters are known only by their initials. In Marker's film they are identified only as 'the man' and 'the woman'.

14 Jean-Louis Leutrat, *L'année dernière à Marienbad* (London, 2000), p. 65.

15 *Peter Ibbetson*, dir. Henry Hathaway, 1935, with Gary Cooper and Ann Harding. In this story, as in Jensen's *Gradiva*, the man recognizes the woman as his former childhood sweetheart only after he has fallen in love with her.

16 D. W. Winnicott, 'Transitional Objects and Transitional Phenomena', in *Playing and Reality* (Harmondsworth and New York, 1982).

17 André Green, 'Le temps mort', in *La Diachronie en psychanalyse* (Paris, 2000), p. 142.

18 'Les poignets ont d'avance un creux pour les menottes'; Marker, 'Lés séparés', pp. 921–3.

19 See Thierry Kuntzel, 'Le travail du film', *Communications*, 19 (Paris, 1972); 'Le travail du film, 2', *Communications*, 23 (Paris, 1975).

20 Jorge Luis Borges, 'The Garden of Forking Paths', in *Labyrinths* (London, 2000), p. 53.

7 Coda: Possessive, Pensive and Possessed

1 Jean-Louis Comolli and Jean Narboni, 'Cinéma/Ideologie/Critique', cited in Francesco Casetti, *Theories of Cinema, 1945–1995* (Austin, TX, 1999), p. 189.

2 Bernard Stiegler, *De la Misère symbolique: 1. L'époque hyperindustrielle* (Paris, 2004), p. 51.

3 Bernard Stiegler, *Aimer, s'aimer, nous aimer: du 11 septembre au 21 avril* (Paris, 2003), p. 53.

4 Laura Mulvey, 'Aberrant Movement: Between Film Frame and Film Fiction', unpublished conference paper, 2004.

5 Laura Mulvey, 'The Pensive Spectator Revisited: Time and its Passing in the Still and Moving Image', in *Where is the Photograph?*, ed. David Green (Photoworks/Photoforum, 2003).

6 Gilles Deleuze, *Pourparlers* (Paris, 1990).

7 Colin MacCabe, *Godard: A Portrait of the Artist at 70* (London, 2003), p. 301.

8 MacCabe, *Godard*, p. 302.

9 My remarks here are in response to what, at the time of writing, is Stiegler's most recent book: *De la Misère symbolique*. In a more recent conference paper, Stiegler has given some indication of the engagement with Freud's work that we may expect from his next book. My impression is that this engagement is with Freud the neuro-scientist rather than with Freud the psychoanalyst. Nevertheless, Stiegler's critique of the techno-logical exploitation of desire by global marketing remains exemplary.

Acknowledgements

The following were first presented as conference papers, or as contributions to lecture programmes:

'The Noise of the Marketplace' expands upon a paper I gave at the symposium, *Cinema: Dead or Alive?*, School of Advanced Study, Senate House, University of London, 14 February, 2003.

'Barthes' Discretion' was first presented at the colloquium *After Roland Barthes*, French Institute for Culture and Technology, University of Pennsylvania, 16 April 1994.

'Jenni's Room' was written for a lecture programme sponsored by The British Council at C³ Kulturális és Kommunikációs Központ/ C³ Center for Communication and Culture, Budapest, 7 July 1997; and revised for presentation as part of the *Millennial Scholars Lecture Series*, Center for Gender Studies, University of Chicago, 7 April 2000.

'The Remembered Film' was first given as one of my *Robert Gwathmey Lectures in Art and Architecture*, The Cooper Union, New York, 29 March 2000.

'Mies in Maurelia' was written for the conference *More or Less Mies: Reflections on Twenty-First Century Art and Architecture*, at the Whitechapel Art Gallery, London, 22 February 2003; and revised for the conference *Representations of Urban Space*, Department of African and Asian Languages and Literatures, University of Florida, Gainsville, 7 April 2003.

'Marker Marked' was presented at the conference *Chris Marker: The Art of Memory*, Institute of Contemporary Arts, London, 17 November 2002.

Many thanks to those who invited me to the above events, and to all of those who participated in them.